CW00449642

SHINE ON YOU CRAZY DAISY - VOLUME 3

COMPILED BY TRUDY SIMMONS

CONTENTS

Volume Editor's Part of the Work © Trudy Simmons Each Chapter © of the
Contributor
All rights reserved
This book or any portion thereof may not be reproduced or used in any manner
whatsoever without the express written permission of the relevant copyright
holders except for the use of brief quotations in a book review.
Trudy Simmons and The Daisy Chain Group International Ltd do not have any
control over, or responsibility for, any third-party websites referred to or in this
book. All internet addresses were correct at the time of publication. Should
these addresses change, we regret any inconvenience caused, but cannot accept
responsibility for such changes.

Printed in the United Kingdom First Printing, November 2021

ISBN: 9781739914844 (paperback)
ISBN:9781739914851 (eBook)

The Daisy Chain Group International Ltd Hampshire, UK
connect@thedaisychaingroup.com

Book Cover Design: Gemma Storey from Infinity Creative
Photo Credit of Trudy Simmons: Nisha Haq Photography

This book is dedicated to....

....All the businesswomen that are showing up and putting themselves out there to be seen and heard. We are all in this together... this is for you to take inspiration, that we are all on a similar journey, but taking different paths, with varying bumps along the way to here.

You can do it! Keep going!

Shine Bright and Shine On.

ACKNOWLEDGMENTS

This is to acknowledge and appreciate all of those that have contributed and shared a piece of their journey with us all in this book. Thank you for your courage and tenacity. You are all inspirational.

As you will read in this book, there are important moments that inspire us to make a change, or force us to look at things differently. These moments can make or break us, they can lift us up or tear us down. It is about how we react; and we can make choices about how we react.

In 2021 we have all had to make decisions about our businesses and make choices about what is right for us and the future. I have made huge decisions personally and professionally about what is RIGHT for me and I am grateful for being able to take risks and know that I am safe, seen and heard. That is all any of us want.

Thank you to my family for their support through the really tough times of the last few years. Mum, Dad, Amanda, Carly, Laura, Tom, Harry - so much love to you all xx.

To the Facebook communities that I run – Hampshire Women's Business Group and International Women's Business

Group for showing me each and every day that whatever we are going through, we are all there for each other. For being the communities that we all call "our lounge-room" where we come to share, ask for help, support, advice and give from our expertise without expectations. I am grateful for the "tribe" that we have and that like attracts like. Community is everything on this lonely road. Come and join ours, it is the best – tee hee!

I stand for inclusion on all aspects. The baseline of everything that we build is on kindness and being available with open arms to all businesswomen that wish to be a part of something and want to be seen and heard. We are here for all of that.

Welcome.

INTRODUCTION

This book is about creating a platform for businesswomen to have an inspirational voice and to share their stories with others, to show that this entrepreneurial rollercoaster is the highs AND the lows and that we navigate them all differently, but hopefully with a tribe/team of people that support our vision to our success – whatever that looks like, and it is different for everyone.

The stories were written in October 2021 – 20 months after Covid hit our countries, our families and our businesses. Things are still raw, but the resilience is there!

Each story is unique, each story is REAL, each story offers a piece of insight, motivation and encouragement when we need it the most.

These are un-edited chapters of real stories from women that have been where you are and have stories to share about how to find your way, not feel isolated, find out what you CAN do, rather than feeling stuck in what you think you can't do.

Here…. Are their stories!! Bong bong…

Charity donation

As we gain, so can we give – that is my philosophy of running my own business. 10% of the profits from this book will be donated to the bereaved families of the NHS who have died while looking after us and our families during the Corona-Virus pandemic.

To find out more, or to donate, please visit this website –

www.healthcareworkersfoundation.org

HINDSIGHT IS A WONDERFUL THING!

Trudy Simmons

They say that hindsight is a wonderful thing...
I was thrown out of home when I was 16 – sounds dramatic; it probably felt it at the time. Within a year after that, I had left college, got a job and lived in a shared house with a bunch of 20-somethings.

I would love to say that it was amazing, but it wasn't; I worked hard at my job and then went home and lived in my little room, living on hot chocolates and cup-a-soups, so that I wasn't in the kitchen for very long. I just felt uncomfortable everywhere.

My job was incredible, I was given responsibility and opportunities to shine. I was working the reception desk in a golf club – stay with me here young-folk... but computers had JUST come in, WordPerfect 5.1 was EPIC, my fingers typed and commanded faster than the system could keep up with, so I was seen as someone who could really support the business growth. I was 17. The people I was working with were older (oh my goodness, like, so much older, like probably over 30 – ha ha!).

They hadn't been to school with computers, so this was all new and scary to them. My confidence grew through helping them, showing what could be achieved, and making systems and procedures work FOR the business.

I loved it. I was given lunch every day from the chef, and I got to arrive at 5.30am to open the doors and turn off the alarm – massive responsibility for a 17 year old. It meant I could choose the morning music for the whole building too – BRING ON WHAM! Blasting through the clubhouse for the first hour of the day – dance party anyone?

I had an amazing group of friends who supported me through that weird-n-wonderful time. I didn't start driving until I was around 20 years old. So for those few years, they would come and pick me up from my job on a Friday night and I would get to be myself and relax for the weekend with them.

I was scared most of the time. I was scared that I would lose my job, I was scared of my living environment, I was scared that I needed to be someone else to different people – and if I wasn't the "right" person, then they would leave me / not like me. I was scared of being seen as not strong, I was scared of not being seen – crikey… quite a fearful time in my life – but that continued for about 15 years of uncertainty, struggling to fit in and that feeling of always trying to people-please so that people liked me.

So how did I go from that constant feeling of uncertainty, to having and owning my own business and growing my confidence? So many different stories to get to where I am now… some good, some funny, some bad, some tragic, some life affirming, some heart and soul breaking.

It would be 20 years before I started my own business. But as I have learned more and more and have DEFINITELY seen in the chapters and podcast episodes from this book and the previous volumes, we all have our journeys to tread, and parts of those journeys become a part of our business story.

I am grateful that I learned from an early age how to look after myself – not well.... But that's another chapter! I am grateful that I'm self-sufficient and a problem-solver. I am a fixer and don't let anything get in my way. I have been told since those early years what I "can't do at your age", where I "can't get to on the ladder, you're too young", what is unachievable and "hard" – MOVE ASIDE, I'm a comin' through.

I often speak to people about living alone in that weird-house and then living in a teeny-tiny blancmange-pink flat on the wrong side of the tracks, and you see their heads tip to one side with the sympathy-stare of "you poor thing". I got the opportunity to live how I wanted to live – I only knew what I knew. I got the opportunity to cook Smash with petit pois and gravy and eat it at 2am (if I wanted!).

Reflection

I wouldn't change a thing – with hindsight. And there is always hindsight.

And that is the thing... hindsight... 20-20 rear vision... looking back... reflection... these are all brilliant and wonderful – but first you have to live it, go through it, feel it, work with it, rail against it – all the things!

Looking back on any situation in your life can give you the opportunity to say and feel what actually happened. The past is the past – though some things are easier to leave there than others! But we are left with the things that got us here (crikey, that's deep, write that one down!).

Over the years between me having that first job and "leaving" home, and the 20 years before I started my business, there are key points and times that have bought me here.

I've been challenged by things that people assumed I couldn't get done. I've been underestimated because I am "naïve". I've had to unlearn some of the things that were

ingrained in me and some of the things that I taught myself, because I didn't know better – and as Maya Angelou said, "when you know better, do better". You can't undo what is done (another piece of gold-wisdom-dropping, brace yourselves for more!), but you can learn from it and know what you would have changed to get to where you are now – OR – know what you are NOT going to change.

My feeling of "not fitting in" had me moving counties, states and countries to find a place for me. I can honestly say that right now, in my life, I'm settled, not searching, not wishing for something that feels like it is unattainable.

Hindsight gives me the ability to say thank you for the challenging times, the times that I didn't think that I would make it (in life or business), because I CHOSE to be grateful for the lessons that I learned, the things that I took away, the fights that I had with myself (the ones that I lost are hilarious!), the 2-year-old-trantrums that I still have as a 47-year-old – you know that that still happens!

What I learned the most from living by myself at 17 years old is that life is what you make it – but hold-the-phone, I can only look back and see that NOW. Who am I kidding? I wasn't an enlightened spirit, running through fields of waving grass with daisies in my hair (or was I???). Think more, early-years-Madonna-sass crossed with Nirvana-angst, the silliness of Captain-Sensible lyrics, the street-smarts of Michael Knight and the dance moves of Carlton. Does that paint a picture??

But life is what you make it. And your business is what you make it. And you can change that at ANY time. And you don't need to explain that to anyone. If something isn't working, give yourself the time and opportunity to look at it and think, "If I changed this now, how would I feel in 4 months' time?".

What do you want?

I have business coaching clients who come to me to be a part of The Happy Business Mastermind, so they work with me for 4 months. The sucky-stucky-muddy place that they come to me feeling is gone within the first month – and the reflection after 4 months is mammoth. BUT first we have to work out what to work out.

I always start with the patterns that have brought us to where we are now. For me, as a Clarity and Productivity Business Coach, it gives me so much more knowledge to be able to help my clients when we can both see how they got to this icky-sticky-bit.

For some of them, it is the first time that they have put all these pieces together. It's the first time that they can see the bigger picture of WHY things are happening now and how to approach things in a different way – I say again, "when you know better, do better" – thank you Maya Angelou.

If things need to change – and ordinarily when business-women start working with me, it's because they do need to change – then work out WHY and what you actually WANT. One of the hardest questions that women can answer is "what do you want?" (picture the deer in headlights face, crossed with the scream face). If we can't answer that, then how can we move forward?

Imagine ACTUALLY voicing what you want, taking the steps to make it happen, putting the changes in place to see the outcome, and looking back in 4 months at what you have achieved. Can you picture that? Is there something that has just sprung to your mind that needs to be looked at? If there is, DO SOMETHING! I am still learning how to have confidence. How to wake up each and every day and look self-doubt in the eye and say, "not today"! I'm not sure that there was a moment that I knew that I could have my own business, but I do know that at each twist and turn, I have taken action, put steps in place,

worked out what I wanted to head towards and what I WANTED to achieve.

If the last 2 years has proved anything, it is that anything can happen. We have pivoted, pirouetted, done cartwheels, and landed with to roaring applause from the audience – right??And THROUGH the last 2 years what have you learned? What has hindsight taught you? What rite of passage have you travelled? What is your story? WHAT DO YOU WANT NOW?

As always, be bold, be brave, be YOU and Shine On.

BIO:

Trudy Simmons is a Clarity and Productivity Business Coach for women entrepreneurs, with a truckload of empathy and a little bit of hard-arse! She helps you find out WHAT you want to do, WHY you want to do it, and HOW to get it DONE! She loves to show her audience how to become more successful by getting clarity, taking action and following through. Trudy has 20 years' experience in helping people move from being stuck and not knowing the next step, to getting their shizzle DONE by finding and harnessing their strengths and removing their weaknesses! She knows what keeps you up at night – the thousand ideas that are germinating in your brain – and she knows how to sort them into "no go", "maybe later", and "hells yes", and get done what is really important to your success.She is the creator and founder of: the Shine On You Crazy Daisy membership, The Crazy Daisy Networking Events, The Accountability Club, The Spectacular Online Business Symposium, The Spectacular Challenge to £1 Million, and The Happy Business Mastermind.

www.thedaisychaingroup.com

2
FROM LITTLE RIPPLES COME BIG WAVES

Amy Wright

The room was swirling around me. I was huddled in the corner, desperately trying not to throw up.

When I'd dragged myself out of bed earlier that morning, the bathroom floor was the last place I'd expected to find myself at 9.15am.

I was going to have to quit my job.

Again.

What was wrong with me? How did I keep ending up here? (The job-quitting bit, not the bathroom-floor).

Truthfully it had been building my entire working life. I'd just gotten really good at ignoring the knot in my stomach every breakfast thinking about another day doing stuff I really didn't want to do.

I'd always found the "traditional" way of doing business quite challenging. The idea that feelings have no place. The constant (and usually unfounded) bragging. Only ever about the money. It all felt like utter bullshit to me.

I didn't dare say any of that out loud though. Instead I'd

simply quit my job and find another one, hoping that this time, it would be different.

It never was.

It wasn't just work

I'd always found it difficult to go along with the status quo. From an early age I'd been full of questions, usually around why things were done a certain way. Especially when something felt unfair.

And I really struggled with the usual answer of "because that's the way we do things".

I remember seven/eight/nine-year-old me sitting on my Dad's knee, him patiently explaining, over and over again, that the world simply wasn't fair, and the sooner I realised that, the happier I would be.

Surely we could at least try to make things better though?

I began noticing that my questions made people uncomfortable.

I got in trouble at school disagreeing with teachers over whether things were fair or could be done differently. Other kids (unsurprisingly) got annoyed at me questioning rules or suggesting 'better' ways to play.

And while I was desperate to make things fairer, making people feel uncomfortable didn't feel very fair either. And it definitely didn't help me fit in.

People liked it much more when I agreed with them, so I started keeping my questions to myself.

They were still there, bubbling away below the surface. But I learnt to keep quiet and adapt my opinions so that no one would feel uncomfortable. To 14-year-old me, that seemed like a fair and sensible thing to do.

It served me pretty well. Until the crushing depression that arrived during my first year at university. There was no

apparent cause and the conversation around mental health was very different 20 years ago, so almost everyone told me to stop wallowing and be grateful for how lucky I was.

So I cracked on, mostly hiding it, scraping through assignments and exams, clinging on to my job, yet barely functioning behind closed doors. Then, when I became "too emotional" at work, (apparently crying mid-coaching session is unprofessional) I was encouraged to resign.

And so began the cycle that led me to the bathroom floor that Tuesday morning.

I'd take on a new role. It would start great. At some point I'd get frustrated, at something unkind or inefficient, and the questions would bubble back up. I'd get tired and emotional when I couldn't change things. Then the depression would return. I'd leave. And look for something else.

I spent the best part of 10 years, 8 cities/towns in 5 different countries, and more than a dozen jobs trying to find somewhere I could settle.

Nothing worked.

Back to the bathroom floor

This latest episode had been triggered by my boss telling me to do something I felt wildly uncomfortable doing. My body was having a physical reaction in protest. But I didn't dare say that to him because I knew this would be the final straw.

After about 20 minutes of hiding, the swirling slowed and a thought popped into my head – what if I wasn't meant to shut up and put up? What if I could do things in a way where I could listen to my emotions and put people's wellbeing before profit?

I marched back into the office (well, it felt like marching, it was probably more a polite walk) and quit my job for the final time.

I was breathless at the possibilities. And I was 100% crapping my pants.

It shouldn't have felt scary. At that point I had more than a decade of experience. I'd worked for big brands, training their people how to sell. I'd managed teams of communicators, run national PR campaigns. I even had a degree in communication. But I knew if I wanted to not hate work, I needed to do things my way. Less business bullshit, more kindness and collaboration.

It didn't quite go to plan

I'd love to tell you I started my business and it was dreamy from that moment onwards. It wasn't.

The things I found so frustrating as an employee didn't magically disappear now I worked for myself.

The expectations of how things should be done. The crush-the-competition mentality. The formalities. The blatant sexism. All still there.

Instead of having one boss, I now effectively had a dozen, who were all independently insisting their project was the most urgent and important.

Desperate to make it work, I was still contorting myself into the person people expected me to be rather than being who I really was. And I was petrified of asking for what I really wanted, in case, you guessed it, I made people feel uncomfortable.

I was getting dragged and pulled around in all directions at the whim of my clients.

It was exhausting.

If only I'd realised sooner that the problem hadn't been entirely down to the job or the people I'd worked for. The problem was me.

· · ·

It was happening again

A few years into self employment, after I'd had my first son, I was unwell again and work was slooooowww. One evening my husband tentatively asked me if it might be time to start looking for a job.

I really didn't want to do that.

In a last ditch attempt to figure things out, I hired a business coach.

Part way through our second call, as I'm waffling on about what I want my business to look like – how it can help my husband, what I want to be able to do for my son, what my clients need, even how I needed to be able to walk the dog every lunchtime – she stops me and asks:

"Yes, but what does Amy want?"

And it floored me. Because I didn't know the answer.

In the process of trying to please everyone else, I had entirely forgotten to please myself.

I had NO idea what I wanted any more. Other than for my business to not feel as hard as it did.

And so began the slow and painful process of unravelling everything I'd learnt about keeping quiet and pleasing other people.

Starting with what I wanted

My business coach turned out to be better for me than any therapy ever had. She helped me find my questions again. And made me ask them to myself.

What do you actually want?

What's going to help you feel comfortable, secure and safe?

Is there a better way to do this?

What feels spacious and fun?

Perhaps most importantly, she helped me see that what I'd always been told was me being difficult, or unprofessional, was

actually me just being myself, and being human. And that was no bad thing.

Rediscovering my voice

I started small. Setting boundaries with clients. Telling them what needed to happen so that I could do my best work. Asking questions and helping them find better and kinder ways to do things.

But sharing my thoughts publicly took much more work. It was a slow and deliberate practice. Easing into being more visible. Starting to express my opinions more. Each time it felt slightly less painful. And each time more and more people who would cheer in support and say "Yes! That's how I feel too!"

Eventually I knew it was time to fully step out of hiding. I took my own damn advice and worked through a full branding process.

It showed me that what I'd always considered to be my biggest weakness, was actually my greatest strength. I saw that it's ok to try and make things better and fairer, even if it upsets some people (as long as I'm being respectful and kind obviously). My voice, and my resolve was getting louder.

The surprising catalyst to it all

Depression runs in my family, so for my entire adult life I'd just accepted it as an inevitable part of me. And I'd put off having kids for fear of passing it on to them.

After I had my first son, I experienced a nasty bout of postnatal depression. It came on fast, without any of my usual warning signs, and it scared me. I didn't want my son to end up like me, so I buried myself in research on how to break the cycle.

I realised that no matter what I told my kids, they would

learn how to be in this world through what they saw. Children learn how to cope with emotions by watching their parents or caregivers cope with emotions. If the adults don't cope well, the children don't learn to cope either.

So I had to learn to cope. It was no good trying to teach my children good emotional literacy, if I didn't have it myself.

It's no good telling them to take care of themselves, if I don't take care of myself too.

And it's no good telling them they can be themselves, if they see me hiding who I really am.

I had to start becoming myself. Taking time for myself. And doing things I wanted to, not what other people expected me to.

When I'd started to become more me, my business started to feel easier. But as I started to be all the things I wanted to help my children be, magical things started to happen.

I've been well for the longest time in my adult life. I've built my business so that it works for me. Not the way anyone else thinks it "should" be done. And I bloody love the work I do. I get to work with some of the most generous, intelligent and interesting people on the planet. And I get to help them make the world a better place.

In allowing myself to be me, I found my calling

All the questions and the insistence that life could, and should, be fairer have become the foundation for my business. What I was always told was my biggest weakness, was actually my superpower.

And it's turned out to be life changing.

It makes people happier – not just my clients, but their teams and their customers too.

And it helps people make more money.

Which is where it gets really exciting...

If we can get more money into the hands of people who are

making the world a better place, then they can make more ripples. And those ripples all add up to create huge waves of change.

I've always wanted to live in a world where everyone feels welcome, and where we're not destroying the planet or people's wellbeing just so we can make more money. And in coming back to who I've always been, I'm finally helping to create a world that's fairer, for everyone. Including me.

BIO:

Amy is the founder of Kind Tide and has been helping businesses transform their communications and marketing from chaotic to calm for over 20 years. How? By bringing more clarity and kindness into the way businesses communicate. Her clients include the NHS, purpose-driven businesses and life-changing charities.

Her superpower is uncovering what makes an organisation magical and distilling that into a beautifully clear brand, messaging and communications. All with a focus on helping those extraordinary businesses reach more people, make more money AND make even more of a difference in the world.

www.kindtide.com

3
WHEN YOUR BUSINESS IS A CHARITY

Melissa Histon

It was April 2010, As I lay on the carpeted floor, staring at the ceiling, thoughts kept flying round and round my mind, 'When I get through this I want my life to be better…I want to have better relationships with the kids…I want a life of travel and adventure….I want my photography business to be super successful…I want…'.

I slowly got off the floor, with a wobble. Dizzily, I made my way to the ensuite and stared in the mirror. I didn't recognise myself; a red, bloated face stared back at me. My eyelashes, eyebrows and hair had all gone but for a few strands. Who was this person staring back at me?

A few months earlier, I had started chemotherapy treatment for the breast cancer that had been growing in my left boob. As time went on, I became increasingly ill from the toxic drugs that kept getting pumped into my body. Lying on the floor, staring at the ceiling and dreaming about how my life was going to be when I got through this was how I spent my days. I had always been an anxious sort of person – a worrier. When I was a little

girl, I would vomit in the carpark before swimming lessons from nerves. When I was eight years old, I started waking at 6am and vomiting before the day had even started because I was nervous about what the day would hold.

Now, lying on the floor, I knew I wanted my life to be different. I wanted to feel calm, be fearless, successful and adventurous. I didn't know what the future would hold for me, but I knew that I was the only person who could change my life.

MARCH 2014

As we disembarked the plane and walked across the tarmac to find our luggage, I knew we 'weren't in Kansas anymore Toto'. We had just arrived at Kathmandu, Nepal.

I was off on a great adventure: with a small team from Newcastle, Australia, my home city, to make a documentary about the sex trafficking of Nepali women and children. In the time since I had finished my chemotherapy treatment, I had managed to grow my photography business, now specialising in corporate work and portraiture.

Funnily, at a business development workshop just a year earlier, I had put on my vision-board that I wanted to go to a third world country to undertake a photography project for a non-profit organisation. I couldn't believe it when I saw on Facebook that a girl I knew was heading to Nepal to make a documentary. I reached out to her to ask if she needed a still photographer for the project. She messaged me, 'No', she had that sorted. But, a few months later, she reached out to me to let me know that the previous photographer had pulled out and asked if I was interested in coming along!

Vision-boards do come true!

For the next two weeks, our little team – Belinda, Daniel, Robyn and myself - were transported around rural and remote Nepal by the Three Angels Nepal team, visiting the poorest of

the poor villages. Three Angels Nepal is wonderful non-profit that rescues girls who have been trafficked and provides them with a place to live and job skills training, so they are not at risk of being trafficked again or falling into prostitution.

After two weeks of hearing the most horrendous stories from girls and women who had been kidnapped, tricked into going with a trafficker with hopes of a better life, drugged, raped, tortured and worse, I was changed forever.

How can a person do such atrocious things to another human?

Coming back to Australia I felt compelled to do something: but what?

I wasn't a lobbyist, I wasn't an activist, I wasn't political.

But I felt a sense of destiny, that I had had that experience for a reason and now it was time to figure out why and what I was going to do about it.

And so I started to meditate on it each day for a month or so until finally the answer came: well, you can write and take photos, why don't you start there? I started The Sista Code events and blog to raise funds for women-based charities and share positive stories of people doing great work in the world.

But I wanted to make real impact. The fire in my belly was lit. Have you ever had that feeling in your gut and your heart? A sense of destiny that you were meant to do this? I followed that feeling and it was the best decision I have made!

Like so many places around the world, domestic violence is a real issue in our community: a problem that no-one has solved as yet. I had witnessed the impact of violence on the girls we had interviewed in Nepal. Blogging and holding fundraising events was nice, but it didn't have the impact that I wanted.

Somebody asked me if I had considered starting a charity? No, I had not.

But the seed was planted and so I started researching, which is imperative before starting any business, for profit or not-for-

profit. I went on a fact-finding mission to determine "was a domestic violence charity needed in our community?" (what were other organisations doing), what does it actually take to start a charity and what does the governance look like?

What I learned:

1. One of the biggest barriers to a woman leaving a violent home is the prospect of having to start her life again with nothing. Women commonly leave a violent partner with nothing but her kids and the clothes on their back. Providing furniture and household items – especially white goods – is vital to help a woman set up a new home, free from violence. This was a gap in the domestic violence sector we could fill.

*Is there a gap in the market you can fill? Who are you serving?

2. Seek advice from the experts for important decisions like starting a charity. I sought the advice from a great accountant and a lawyer who specialises in not-for-profits. He made sure that we established the right business structure to register with the Australian Securities and Investment Commission, the right charitable purpose and category with the Australian Charities and Not-For-Profit Commission and the Australian Tax Office to receive tax concessions.

* Get the right advice and register with the relevant business authorities.

3. Charities are highly scrutinised in terms of their governance, i.e. the processes, activities and relationships that make sure a

charity is effectively and properly run and in compliance with the law. It is best to set-up processes, procedures and reporting activities correctly from the very beginning to ensure the charity is always compliant with the relevant government departments.

*Operate with integrity and ensure you have the right processes and fulfill your compliance obligations.

With some very important consultation – over a few wines with my friends – I decided to name the charity 'Got Your Back Sista' (GYBS). The first year I ran GYBS from home. Though I established a Board of Directors, which is needed by law, I did the majority of the work myself that first year. I was totally winging-it, figuring it all out as I went along. I also made the decision to let go of my photography business; I struggled to do both.

Referrals started coming in from other DV services to provide furniture and household items to their clients: women fleeing violence and setting up a new home free from abuse.

I found it was really important to establish positive relationships with other DV services, and also suppliers: businesses that would provide the furniture and household items, often at very reduced prices and free delivery.

Financially, I was hustling! I held a fundraiser to raise $15k to get the charity going – which was a great start, but the key to establishing a sustainable organisation is to ensure regular income keeps coming. Even though GYBS is a non-profit, it is still important for us to operate and make a profit each financial year. It ensures our ongoing viability. So generating income is key!

Got Your Back Sista is approaching six years old! We are self-funded – we don't receive government funding – so I have had to be creative in finding various streams of income, such as

events, fundraising appeals, corporate partnerships, corporate grants and doing lots of speaking engagements. We have also created a side business to fund the charity, an Op Shop called Village People.

I have learned that engaging community, making connections and collaborating with other people and organisations is key! It's all about people.

The first year of running GYBS, I made appointments with numerous people from business, corporates, community organisations and funding bodies, to tell them about GYBS and ask if they may wish to be involved in some way and/or pass on educational information about domestic violence to their colleagues. I still do this today.

If I was meeting with a funding organisation, I ask the question, 'What do we need to do to be funded by you?' and, 'Is there anything Got Your Back Sista can do for your organisation and people?'

Got Your Back Sista has grown significantly since its humble beginnings in my house. We now operate out of a beautiful big old building we named Village HQ. We needed the space as we have also grown our program offerings to women in the community. Our Board decided in Year Two that we needed to give a hand up, not just a hand-out. How can we empower women to thrive and have a happy and independent life?

So, we now run various workshops and programs at HQ to help women rebuild their lives. Counselling, an Empowerment Circle, workshops to build confidence and self-esteem, educational programs to give women a qualification so they can find employment, self-defence classes and life skills like cooking classes and financial budgeting classes. I believe that our main purpose is to serve and support the women who come to GYBS and we can best do that by always looking to fill the service gaps that other organisations cannot or do not provide to support women in need.

Having the right people and organisational culture is so important. I made some mistakes early on when hiring people, I was just desperate to get help so I didn't do enough research into a person's background and skills. Fortunately, we now have a great team: four employees, six contractors and 65 volunteers. Life is so different for me now, since I was lying on the floor of my room dreaming of a new life. I have found my purpose, have built a successful charity and am living the life of adventure I dreamed of. Best of all, I know I am doing good in the world which fills my soul and helps others to build their best life!

BIO:

Melissa Histon is a woman on a mission to give women a voice. After experiencing a number of life-altering events, including breast cancer, Mel created an online community called The Sista Code in May 2014 to see women empowered, happy and connected. The Sista Code has grown into a community of wonderful women that empowers other women. In January 2016, Melissa founded the charity, 'Got Your Back Sista', which empowers women to thrive after leaving domestic violence. Melissa was named, 'Newcastle Woman of the Year' (2017), received 'Rotary Inspirational Woman Award' (2021), and was a finalist in the 'Newcastle University Alumni Awards' during 2017. In a further bid to lift and give women a voice, Melissa launched the 'Hey Soul Sista' podcast in September 2019. Whether it's interviewing inspiring women from around the globe, or creating programs and campaigns to support women escaping violence, Mel knows that true change can only happen when we all stand together and boost each other.

www.melissahiston.com

4

FINDING PURPOSE THROUGH PASSION

Dawn Gatward

W hen I was younger, I used to stare out the window and daydream about changing the world!

I found my inspiration through books and TV (social media was yet to arrive) - Buffy was badass, the Charmed sisters had epic powers, Rogue from the X-Men comics oozed sass, and Wonder Woman was a goddess - I mean, you can't get much better than that!

I wanted to be just like them.

I longed for purpose; something I was born to do, that would help others and make the world a better place. I saw myself travelling and having adventures. I saw myself on stage. And I saw myself enjoying all the abundance that was available (we're talking millionaire status).

I'm pretty sure my entire family thought I was weird, but I mastered quite quickly how to blend in (aka be boring). I went to university, got a job (or a few), got bored and then started a business.

A smoothie bar in fact.

I doubt I would have done it if it wasn't for the partnership with my then-boyfriend. My confidence in myself was pretty low so it was easier to lean on the support of another person, which I have done with style (too much style - it was more like a codependent habit that I would one day break free from, but that's another story).

With a damn good business plan, a generous bank loan and a bucket load of determination, the business opened in the summer of 2007 - the wettest on record, when Rhianna's 'Umbrella' taunted me for weeks and turned away the customers. Needless to say, changes had to be made... quickly!

Business lesson #1 - things don't always go to plan

Many new things were tried, and the smoothie bar eventually transitioned into an independent coffee shop.

It was harder than I thought. Bringing in customers wasn't easy, the hours were stupidly long and the outgoings were never-ending.

Over the span of ten years the location changed, my social life became extinct, children were birthed and my relationship ended. Note: business partnerships aren't for everyone and I found this out the hard way.

Being in business is in fact the hardest and fastest way to personal growth!

Life is challenging enough, but in business your emotions are amplified and all those pesky fears and limiting beliefs will come knocking.

I criticised myself on a daily basis, questioned my decisions, compared myself to my 'competitors' and started to think that I wasn't good enough to have a business. The reality was far from what I expected, and many times I thought about giving up and returning to employment.

I didn't realise it at the time, but I'd fallen out of love with

what I was doing - I carried on anyway, blind to my own desires and committed to the 'you've gotta work hard to be successful' mantra that society had drummed into everyone.

My unhappiness turned to resentment, and this had a negative effect not just on myself but on everyone around me:

- I saw customers as an annoyance (and treated them as such) - rolling my eyes when they made 'stupid' requests, huffing when they tried to make conversation, and snapping when the less friendly ones turned into demons.
- And I saw my staff as status tokens (I mean, it seemed like such an awesome thing to brag about - it meant the business was successful, right?) But my poor staff could never live up to my expectations. I was practically selling my soul every day and I hated the fact that they weren't doing the same. They weren't invested in the business, it was just a job to them. I'm pretty sure they all hated me

Things carried on and I didn't recognise the signs until I was deep in the mud. Alcohol had become my saviour, and helped make things easier each day. It was my go-to but only fueled the emotions I was already feeling - worry, stress, depression, anxiety.

Looking back, I was an awful person. But it was only because I was living for others. I wasn't putting myself first or doing what I wanted to do.

Business lesson #2 - follow YOUR dreams, not anyone else's

And then that life-changing day came.

It was one of those days that didn't feel so special at the time, but when you look back at it you realise how massive it was.

December 31 2016. New Year's Eve

A day when everyone celebrates all that they've achieved and gone through, and look forward to all the possibilities of what's to come next.

But it wasn't like that for me. I was completely miserable. Things at home were toxic, there were constant arguments and I'd resorted to sleeping on the office floor just to escape it. And only a month previous I'd had my second miscarriage - with no support around me, it hit me really hard and made me feel like even more of a failure. I'd considered running away, moving to another country and never seeing my family again. I'd even thought of 'easy' ways to end my life.

I had no friends and no plans. And as I sat there, alone, everything suddenly hit me. Being in business was supposed to give me independence and freedom, but I had neither. There was a huge emptiness inside - I was unfulfilled. There had to be more to life!

I was drunk on prosecco, drinking from the bottle and crying ugly tears. And then it happened...

It was like my body took over. If I hadn't been so drunk I would have thought I was crazy and talked myself out of it.

I lit a candle and wrote on a scrappy piece of paper:

"Dear Universe. Please help me. I want to be happy"

*Then I burnt the f**ker*

Three days later and a chat with a psychic, I was told that things were about to change. I hadn't been paying attention to the signs so things were going to be taken up a notch. Weird, but I was intrigued - all the talk of guides, angels and spirit seemed to stir a curiosity inside me.

Within the next 48 hours I was struck down with an unexplained full-body infection that resulted in multiple hospital visits, and plenty of hallucinogenic nights. I remember the nightmares, the conversations with people who weren't actually there and the overwhelming urge to do a Reiki course...

Getting attuned to Reiki was like a veil had been lifted. I felt like a brand new person, and knew that I wanted more. I was ready to soak it ALL up. I now considered myself 'spiritual', and my thirst for knowledge became my ladder to purpose.

So what did this now mean for my business?

I decided that it was no longer something I wanted to do, but I couldn't just give it up and walk away. So instead, I reduced my hours and split the business with my partner (who'd gone through his own darkness, and was willing to be released back into the wild after suffering at home with the children).

Having time at home felt alien. And it definitely took a while for me to get used to a new way of 'being'. My spiritual journey was my companion though and over the next few years I had to do a LOT of inner healing - I think people assume personal development is easy-peasy-lemon-squeezy, but there's so much shadow work to sift through that most of the time it feels like sitting in the dark with all your demons looking at you. But at the same time it's weirdly satisfying and rewarding, especially when you look back at the changes that have happened.

And one of those main changes for me was starting over with a brand new business, all by myself. But this time it was online and this time I had passion. I wasn't letting anyone else take the lead, and I wasn't nodding my head in agreement to what anyone else wanted. It was all for ME!

But I'm a true Sagittarian entrepreneur - I wanted to learn everything and I wanted to do everything! So I did.

I went from selling £5 tarot readings on Facebook, to making crystal jewellery, to reading people's birth charts, to giving Angel guidance sessions and Unicorn healing, to then really putting on the business hat and getting serious.

That little girl who used to look out the window and daydream about changing the world, she was back to remind me that I still had a job to do.

I invested my time into learning more about business -

branding, marketing, social media, automations, web design, creating offers, launching etc (you could say it became a mild obsession).

This was what having an aligned business felt like. I was loving every second of it, and happily spent hours on my laptop - creating Instagram posts on Canva and putting together courses / freebies. I was teaching and coaching other people, and saw the results that I was having on others. Seeing the ah-ha moments and wins in other people's lives is the biggest buzz ever. It became bigger than just me!

Business lesson #3 - it's never just about you

But alignment isn't always easy and doesn't always flow. Being aligned with what you're doing means having passion, and truly loving your craft - but this is business and there's always going to be challenges (that's life).

I've had many offers that didn't sell, I've had hateful comments on my posts, I've had no comments on my post, I've forgotten what I'm saying on a live, I've had tech problems galore, and I've had days (sometimes weeks) where I'm so unmotivated that I don't do a single thing.

But that passion and that love for what I do means that I find a way through all of the struggles, and make the tweaks that are needed for my growth.

And all that growth has led to where I am today. A Soul Coach for female entrepreneurs who want to change the world.

My entire journey has been necessary so that I am now able to pass on my wisdom to those who are also going through similar things. I help women honour their shadows, and transition through them with love. I help them connect to their magick and to their soul purpose. I help them expand their consciousness so they are able to create a vision of their future, and fully live with passion. I frigging love what I do!

I'm still working towards that millionaire version of me, but the things that are emerging are exciting. Every day I'm learning something new and getting closer to those dreams I had as a child. And although I'm not on the stage just yet, I'm creating a small ripple effect of change in the world - and over time this is going to get bigger.

Wonder Woman would be so proud of me. I've finally found my purpose, through passion.

BIO:

Dawn helps spirited entrepreneurs find their purpose and get aligned AF.

Some call her a Soul Coach, but she is also a Priestess, a Consciousness Mentor, an Aligned Business Strategist and Moon Marketer.

Her aim is to help you become the greatest version of yourself. Dawn is here to show you what's possible, to help you fully connect with your soul and unlock the passion and vision that's within. She unites your Feminine with your Masculine, so you're accessing and leading with your intuition but also taking inspired action.

www.dawngatward.com

FROM BURNOUT TO BLISS - HOW TO CONNECT THE DOTS

Natasha Mincella

My story begins with me, collapsing under the combined weight of a load of angry dentists (not playing 'pile on' – lol – but dentists desperate to sell their businesses...and the weight as their corporate lawyer felt unbearable). And also, with me sobbing day after day in my kitchen and at my desk. I walked around like a zombie. I felt dead inside. It couldn't go on.

The accidental lawyer

I'm a creative person who accidentally became a corporate lawyer. I know - it's hard to imagine how you can become something so serious-sounding by accident. But it does happen – maybe you can relate?

When I was a child, I had blind faith I would end up doing something fab. I just wasn't sure *what* exactly. I was waiting to find THE THING. You know – that exciting thing that I was really good at. And then everything would slot into place.

Only it always stayed tantalisingly out of reach. There was nothing I truly cared about. And ordinary people like me didn't do the amazing stuff (acting, dancing, tv producing, writing, painting) did they? There must be a secret path to those things - for the chosen few. Not for the likes of me.

I didn't give up hope but as time went on, I was moving up through school and having to make decisions about my education and which direction I was headed.

I found exams easy; I was an academic kind of person. So I chose subjects I really enjoyed and breezed on through. I ended up doing really well in my A levels and went to Cambridge. I had a wonderful time. I discussed literature all day and I raved all night (it was the early 90s). I had a ball.

But at the end of that time, I STILL had no idea what I was going to do with my life.

The 'sliding door' moment

And then one day I remember my dad saying to me,

"Natasha, why don't you give the law a go? Women seem to get on in the law and it's reasonably well remunerated [exact words – funny how some words stick in your head]. It'll be useful training whilst you're deciding what you really want to do."

And just like that, with those seemingly innocuous (and sensible) words I started off on a path to a very unhappy couple of decades of work. Decades! As in 20 years!

Things started well. I was lucky, I got a great training contract at a top city firm. It was glamorous - a glorious combination of Suits, LA Law, Ally McBeal. A whirl of marble and brass, canapés and champagne.

I was only 25 and earning a lot of money. It was the 90s: flat in Notting Hill; married to a Britpop star; hanging out with Oasis and Paul Weller at the weekends. On paper I was living

the dream but I struggled massively with what I call the 'corporate mask'. In my job there was just a way that you were expected to behave every day and I found it so claustrophobic. I was miserable and felt completely dead inside.

After a few more years in London we needed to escape the (by then) toxic Britpop machine. I resigned from my city job when I became pregnant with my first child.

You did what?! The opium bed years.

We moved to the countryside and when my daughter Florence was still a tiny baby, I started a business with my wonderful mother. In fact when Flo was just 6 months old I went on a trip to Java, into the jungle, randomly following leads to cool furniture artisans so I could start my new business ofdesigning and importing furniture made from reclaimed teak.

I learned so much in this time. My mum and I fulfilled every single role in this business. I suppose the most important and surprising thing I learnt is that I've got real entrepreneurial spirit. That had somehow stayed hidden as a child and my education hadn't tapped into that rich seam.

A few years later my marriage to my musician husband ended (we met when we were 18 – by the time we were in our late 30s we had both changed beyond recognition) and I ended up doing what I swore I would never do – I went back to being a lawyer.

I wanted to stand on my own two feet and support my 2 children myself if I needed to. And being a solicitor just seemed like the most sensible way to do this. But, oh my goodness, I was just as miserable as before. It sucked the life out of me.

I kept trying different things to make it work. I changed firms; I used a career coach; I spent two years working in a specialist IT law firm (God, it was AWFUL!).

And that brings me to where we started: with me crying in the kitchen....

In praise of soul-searching (and Instagram)

Something had to change – and it was reaching rock bottom that gave me the energy – borne of absolute desperation.

I asked myself - what do I want my life and career to look like?

I looked to see other women with families who had jobs or businesses that I liked the look of so I could find clues; the breadcrumbs to follow. This was about six years ago and I really struggled to find anyone to inspire me - definitely not in the law - but to be honest I couldn't see any women in other businesses in the UK that I wanted to emulate either.

So I had to widen the search and it was on social media, and in particular the early days of Instagram, that for the first time I found business women living the kind of life and having the kinds of businesses I aspired to have. Where I could be completely myself and talk about the things that matter to me: soul and freedom and balance and joy. All the things that somehow I hadn't been able to talk about in my traditional legal job. I felt more alive than I had in years and heady with the sheer possibilities.

I spent 2015 soul searching – whilst just keeping my corporate job going, giddy with the knowledge that I was on my way out!

I invested in myself and it felt scary. I did B-School, which is Marie Forleo's online business program. It felt like it cost an absolute fortune....but it opened my eyes more. I researched online and found workshops which started to speak to a new generation of values driven women and non-binary business owners.

At one of these workshops (it was a Danielle LaPorte desire

map workshop) we did an exercise to work out our 'core desired feelings', the way we want to feel on a daily basis and how to re-examine and revisit our goals in light of this.

I loved it. And I had an epiphany. The workshop was on a weekend and on the Monday morning I handed in my notice.

I remember driving home from my last day in the office. I wept with absolute joy. Nothing has ever felt so right….. And the business coach who had run the workshop became my first client (she's still my client today).

Joining the dots

Six years later, I'd love to say it all went like clockwork and was an amazing overnight success. That's not the truth of it, but right from the start, I felt so much better. So much more myself. It was an overnight success personally, even if financially that wasn't quite the case.

Inevitably I went from being an employee to being a self-employed consultant, was maxed out with one-to-one work, and then took time to work out how things should evolve. But I continued to follow my nose and my heart . Word spread organically amongst coaches and mentors. I listened to the feedback I was getting and it was the most natural thing for me to end up specialising in helping coaches.

I went deep into this area of specialism and that was one of the steps that took my business to the next level. I also wasn't scared to be inventive and explore and experiment beyond the usual legal path. This allowed me to develop some really innovative ways of helping small businesses with their legals, which doesn't involve them breaking the bank. I am really proud of this mixture of law and creativity (at last!) and how it helps people.

It's an absolute win-win all around. Six years on, I've managed to double my corporate salary. But most importantly

of all, I have absolute freedom to do and shape my day, my week, my year exactly how I want. I am also looking at ways to get my husband out of his corporate job so he can share the joy. I always knew that freedom was a crucial part, but I wasn't sure entirely what that might look like...

The icing on the cake

In an incredible turn of events at the start of this year, in the midst of a global pandemic, having never even had a speaking part in a school play, my 15 year old son ended up doing a zoom audition for a new HBO TV series - and got one of the lead roles [side note: it turns out normal people like us CAN and DO get amazing jobs, all you need is a willingness to be a bit vulnerable and put yourself out there, and have a mum to record you on their phone and send it off....who knew?!!].

My son has been out in Brussels for the last six months filming the show, and I've been able to spend big chunks of time with him out here, running my online legal business from my laptop on set, in his dressing room. And my goodness – are we having a blast!

One of my clients recently described me as the 'least lawyery lawyer ever'. It's one of the best things anyone's ever said about me! I hated being a lawyer for 20 years but now I love it. I have gone from being stifled by the corporate mask, to being 100% myself. In the flow. In every way.

My one big piece of advice would be to trust your instinct and believe in the process. Take the next right step; assess; course correct; then take the next right step again. Even if sometimes it turns out not to be quite right after all, it will lead you to people and places that will lead to the next thing and so on. Before you know, it, you're living that dream life.

When I think about everything I wanted five years ago, how I wanted my perfect day to look...I'm here. I'm doing it.

. . .

BIO:

Tash Minchella is a city trained lawyer with over 20 years experience. She specialises in helping coaches, mentors and values-driven online businesses to get their essential legal documents in place so they feel safe to do their best work. The main way she does this is through her online legal memberships for coaches and small business owners. This means small business owners can get all the legal documents they need - and the support surrounding them - for a low monthly fee.

The best part of her business is seeing the huge transformation in her members' businesses (and confidence) when they get their legals sorted. A legal service with good vibes guaranteed!

www.the-orchard.uk

PLANS HAPPEN WHILST DREAMING

Sue Kerrigan-Harris

A few weeks ago, my 7 year old son asked me how many jobs I'd had. His Dad Rhod laughed a good belly laugh as he knew I'd had quite a few! I think we counted 30 jobs. I took a moment to think about that and I chuckled to myself. That's 29 jobs between the ages of 16 and 30 and 1 job (that's a bit of a lie but keep reading..) from 30 to 49 and beyond!

I never knew what I wanted to do. A 5 year plan? I didn't know what I wanted to do next week, let alone in 5 years!

I left school with some pretty average grades which felt like terrible grades. I thought I was at the bottom of the pile and a bit thick! My A Level results were poor too.

Plan A

I went to work as a Glass Blower's apprentice. Exciting, different and interesting but after a while I realised I was a production line for small ornaments. There was something

missing. I love being creative but I wasn't using my brain much and I was bored.

So I did the total opposite and got a job as a Clerk. Oh my, that was the worst job ever! I had a pile of filing that never got lower. I'm really not sure how it didn't topple over - it was nearly a foot high! So I quit and found another desk job that was better.

I had a few of these desk jobs. Did I say that filing was the worst? Hmmm, I think maybe the Insurance job was the worst; I was afraid to leave my desk because whenever anyone else left their desk the boss would be nasty and talk about them. It was horrible. So needless to say, desk jobs and the whole environment of having to do the same thing every day 9-5 and wearing smart clothes and shoes (oh my, the shoes - give me trainers any day) was most definitely not for me!

Plan B

I came to the conclusion that I could be bored and miserable for the rest of my life or take a few years out and go back to College and do something I really wanted to do.

I spent the first 6 months at College doing a teaching degree and then I quit. It just wasn't for me, but I did enjoy the idea of teaching - just not in a big classroom.

Hold that thought.

Thankfully I switched to a degree in Design and Technology. It was the best time because for the first time I was naturally good at something and I loved it so much! It was a little hard getting my head around the fact that I was good at something. When I'd only been, at best, mediocre at most things.

3 years went fast and I left with a 1st Class Honours Degree. Wow!

. . .

Plan C

So now the world was my oyster right? Hmmm... well that isn't how it turned out. I got a job with a broadcasting company. Lucky me!

Hmmm, no.

It was really boring, I was on a computer from 9-5 again - another production line job! And what was worse was that I was sexually harassed. It was awful. I can't even write what happened and it happened in front of managers who should have stopped it.

What actually stopped the harassment was that I wasn't very good at the job (bored to tears) so I was confronted with the boss and the HR department and I explained the ugly truth. I was whisked away to another site and given a new job immediately. It was the best thing that ever happened. By sheer luck I was given a job I enjoyed. A project to work on which turned into my very own project. I designed a visual computer program to enable the sales force to cost their systems. Ha! Doesn't that sound boring? But it really wasn't, because it was mine and I could be creative and use my brain! It was truly wonderful! This was the start of something special.

I ended up doing this job for a good few years but in the end I got bored and took voluntary redundancy but with a self-employed contract to do the same job, giving me free time and a job.

Plan D - The Final Job - Self Employment

With this extra time I always had a dream of having my own business - somehow.

I had a vision to have an online shop selling something. That was as far as the vision went!

. . .

Plan E

An interesting turn of events happened in that my mum had trained to be a reading specialist (she was a teacher) and she was able to teach me how to teach children to read and so I had another string to my bow - a private tutor. That drive to teach never left me but I just needed a better way of doing it that worked for me.

Plan Oh My, Where Did This Come From?

Somehow in this mix I trained to do Indian Head Massage and became a mobile therapist. I certainly wasn't bored with 3 jobs on the go!

Back To Plan E

Teaching children to read, I came across children who were Dyslexic and the more I taught them the more I realised that the struggles they had with reading were the same struggles that I had with reading and I realised that I was Dyslexic too. I muddle words when reading and muddle words in writing. I mix up spellings with putting the letters in the wrong order and I have short-term memory issues. Everything started to make sense; I wasn't thick, I'm Dyslexic. I just hadn't been taught the right way for my brain to learn. And here I was teaching children the right way for their brain to learn because I understood their brain. I also learnt how to spell better! Another WOW moment and an idea for my online shop was brewing.

Plan D Part 2

I learnt how to build a website and an online shop. A huge learning curve - I loved the challenge! To teach children how to read and do maths I created board games and I sold them in my

shop. I created a product for children who struggled with B and D letter reversal issues and maths board games for reluctant learners. I tried to draw the pictures for the games but it was a big flop. I couldn't draw cartoon style. So one Sunday morning I got up and told myself that I was going to do my absolute best and learn to draw cartoon style. I grabbed the paper and pencil and failed miserably at cartoon drawing. But what I did was a pretty realistic drawing of a girl! I posted it on Facebook and got some amazing feedback which encouraged me to keep drawing. In the meantime, I hired a cartoon artist to draw my game images. And I won the Networking Mummies Award for Best Product. Wow! It was amazing and I feel proud of that but I still felt that I really wasn't there. I wasn't doing the thing that inspired me. I wasn't passionate about what I was doing. I wanted to wake up every day and feel inspired and proud of my achievements.

Not In the Plan At All (not that there was a plan!)

Around this time I had a battle to overcome. A lifelong condition called Uveitis, a sight threatening condition. It started to rear its ugly head and because of complications my sight was in danger. Fortunately after lots of medication and two operations my sight was saved.

In 2013 I had my beautiful son Oliver and my world turned topsy turvy! How on earth was I going to bring up my son and hold down 3 jobs? I couldn't return to teaching children; I had developed an underactive thyroid and couldn't think straight or keep a single thought in my head. I struggled on, not really achieving much as there was too much to do. But I was still drawing and working for the broadcasting company and running my online shop. I quit the Indian Head Massage. In the end I realised that I just needed an Indian Head Massage myself!

. . .

Plan F

Christmas 2015 my sister, out of the blue, bought me a set of 6 pastel pencils for skin tones. She said "I thought you could colour them in." Meaning my pencil sketches. Oh I laughed but duly got my sketchbook and coloured one in. "That's nice" she said. I looked at her through suspicious eyes but thought, okay I may try another, so I did. I did a very dodgy looking child's rendition of a girl with a magenta face and blue hair! But she loved it. It was so lovely because no one had expressed so much excitement about my drawings before.

I kept drawing and showing my sister and she kept encouraging me with kind words. I took over the dining room with my new found love. It was exciting and I was driven! I kept posting my work online and I started to get commissions. The thought of earning money from drawing had never occurred to me. But here I was doing it and I finally knew what I wanted to be: A Portrait Artist. I never even stopped to think that it's probably one of the most difficult professions in the world to earn money from because I was earning money and I loved it. I had blinkers on, a one track mind to success.

I cleared out the shop stock to create space - with not even a thought I was doing the wrong thing. It felt so good, it had to be right. I rearranged everything into an Art Studio and built a new website to showcase my work.

WOW WOW WOW! But what about the teaching and the online shop?

I had joined a local art society and they asked me to teach the members. The result of which was the class asking me to start a weekly art group to TEACH them! So I did.

Plan G

Then the pandemic hit the world. My art class stopped. All my class members were in the vulnerable category / living

alone. I had to do something. Zoom! I had all the gear to do it but no idea how. But we did it anyway. I even helped other art teachers setup once I'd found out how. And thanks to the pandemic I started teaching online and selling my tutorials on my website - the new shop. So here I am today, a professional artist and teacher, teaching students from all over the world. I've been recognised by a British world-leading soft pastel brand and have the honour of being an Associate Artist together with only 30 other artists from around the world. I've won 2 competitions, I have paintings in a Hampshire Gallery and I have my very own Art Studio. I finally found my me; it's not boring - it's different every day. It's totally exciting, I can wear what I like and I'm teaching. I really do have everything I ever could have dreamed of, even though I didn't know what the dream was when I started. If like me, you don't have a plan, it's really ok because you too will get there, even if you don't know where you're heading. Just keep going.

BIO:

Sue Kerrigan-Harris is an International, Award Winning Portrait Artist and Art Teacher. She teaches people in her own village in Hampshire UK and teaches internationally. Sue is an Associate Artist with the world renowned Soft Pastel brand Unison Colour. Sue loves to paint people, pets, horses, wildlife and of course, she loves to teach. Art makes her heart sing and her soul smile!

www.skhportraits.co.uk

MORE THAN CARTWHEELS

Alison McMullan

A t this point in time, I've spent half my life in business, well 2 months short of it. Who would have thought I would get this far? Not many I can assure you! I'm the founder and CEO of a multi-award-winning CIC (Community Interest Company) which has grown immensely since its establishment 22 years ago.

Sounds impressive right? Gosh it was so hard to write that but, that is how I should see it. For far too long I've always seen it as this: Alison McMullan, a gymnastics coach who, along with a growing team, gives opportunities to everyone to participate and excel in gymnastics.

I love what I do, and it has brought me, my team, and my gymnasts many opportunities and experiences. It's difficult to really see what I do as a career which is why it has been difficult to convince other aspiring coaches and young leaders to take the leap into a career in coaching gymnastics. You see, many said a business in sport was not possible, many said I didn't have

the ability to do it (I've always been a dreamer), people would have asked "but what is your real job?". How can you make a career out of cartwheels? Well, let me tell you what it's all about, but more importantly………. 'WHY' I went for it!

Know your 'WHY'

When starting out in "business", I didn't have a clue what it was all about, all I knew was the reasons WHY I wanted to PROVIDE a gymnastics club. As a teenager, it was a goal of mine to learn how to do a back flip. I joined a local club aged 15 and within 6 months I was helping all the little ones in the class. I didn't have a 'technical' clue what I was doing but what I did have was a passion to learn, a connection with the children and an understanding that with the right amount of encouragement and support, you can do anything! I had a few experiences in the club which, even at that age, I just felt weren't safe or positively influential. This made me think about the possibility of doing it my way. So, there it was, my first 'WHY': *to provide a safe, fun, and positive environment for children to thrive in our sport.*

Growth

Growth just happened, I didn't like to look ahead too much, I didn't even think about whether it would be successful or not. I didn't really think about failure or success, I just loved what I did and had some talented little girls. As the club grew, we needed to expand. Firstly, we took on an additional two nights in a school as well as our two nights in a leisure centre and when we had more on our waiting list than we could put in our classes we had to open full time. What do I do from here? The search for a unit large enough was difficult, we found many over the next few years but none of them worked out for

various reasons; planning issues, asbestos, costly upgrades, but in 2006 we found the ideal industrial unit and opened the doors full time in January 2007, exactly seven years after our first class! Within three years we had more than 500 families attending classes, employed 17 staff, and had connections with nursery schools, primary schools, and universities. It wasn't an easy ride, but I'll get to that later.

Talent, Opportunity, and Resilience

Gymnastics wise, I knew what I was doing (kind of). I mean I still had a lot to learn but as our gymnasts got better, I knew I had to develop further. By 2009 we had our first gymnast qualify to represent Northern Ireland. Then disaster struck, a broken foot which required surgery, pins and plates was enough to end a gymnast's career but not this kid! You see Sophie taught me a lot, in life and in gymnastics. She was an incredible little girl, from a shy 5-year-old who cried on her first day to a physically and mentally strong young woman who was determined to succeed. She wasn't supposed to do gymnastics again after that injury, but at 13 years of age she was undaunted and knew she'd overcome it. The only days she missed training were the day of the surgery and the day after surgery. Her outlook was "the rest of my body works so why can't I train" and so she did. Sophie went on to compete at World Championships in 2011 aged 16 and numerous World Cup and European events until she retired at the end of 2012.

Sophie sacrificed a lot: parties, days out with friends, even family holidays but it was what SHE wanted, and I went with it. Being a World Class competitor had its downsides, the pressure on your body and on your mental health is astonishing. This was where I, as her coach, needed to stand my ground. My gymnast's mental health is of utmost importance to me, and I

just couldn't put the pressure on any of them to fit a certain mould. They are all individual, all have strengths and weaknesses and will all succeed in their own way. As a coach I was criticised for giving my gymnast a voice, for allowing her to have a say in how she trained and for building a relationship with her rather than a dictatorship. Sophie taught me what resilience was, to never give up on your dreams and to stand up for what you believe in.

Having an international competitor brought attention to our club and more opportunities for the talented gymnasts and myself. Suddenly every gymnast wanted to go to the Olympics! As the training hours ramped up, the commitment increased, the membership numbers grew. Success breeds success!

New facility, new challenges

By now we had relocated to Belfast, not through choice, a planning issue forced us to close so we had to look for another venue. At the time I thought the doubters were right, "it wasn't meant to be" but by flipping the coin and realising that "it WAS meant to be, it just wasn't meant to be there", it was up to me to ensure we carried on. It was with the help and support of a local church, in particular Pastor Jack McKee that we settled on moving to West Belfast.

Belfast wasn't the ideal choice in fact people thought we were mad moving to an area with a history of political unrest, an area of conflict for more than 30 years, an area of social deprivation (ranked 4th of 582 most deprived areas). How would you see it? Reminding myself of my "WHY", this was an opportunity to bring something to a community who needed it. Our club had the ability to help this area grow and highlight the positivity that this area can bring. Things were changing in Belfast. This area was becoming an area of interest especially for tourists, we just had to help get rid of the stigma.

It took time to build confidence and change peoples' opinions of West Belfast. Our membership dropped, our facility was smaller, and it was difficult to 1) gain trust in the local community, being an 'outsider' and 2) attracting new members to an area rich in troubled history. But wasn't that what we were about? Regardless of who you are or where you're from, we welcome you, we continued to create that safe, fun, and positive environment.

New talent was emerging, right under my nose and I didn't even see it. Sometimes I became so involved in one thing, I didn't notice what was going on around me. You see, having an elite athlete takes serious commitment from the coach. I sacrificed a lot too, but I enjoyed the opportunities it brought me and, even though it took a long time to see it, I've learnt a lot about myself and how I've grown as a person not just a coach.

Managing emotions

Hannah was a little gem, she's always been there, giving her best, looking up to the older gymnasts and being a real part of the team. She had built such a trust in me that she would try anything I asked because she felt I knew her capabilities better than she knew herself. It was through Hannah that I really developed my coaching style. Engaging in discussions with my gymnasts has always been important to me. I feel it's necessary to make real progress, to ensure we all have clarity on our expectations and to ensure they are committed to learning; however, I needed to know more. I needed to get inside their heads and find out what really makes them tick. I didn't want my gymnasts to do things because they were afraid of me or afraid of a 'punishment' for not performing a certain skill. I wanted my gymnasts to be able to manage their emotions, to understand why they felt fear and to give them the tools to deal with it. I read…. a lot! And I discussed this with them…. a lot!

We now talk regularly about our "chimp" (emotion) and how to calm him down, they even have names for their own chimp. I was good at getting my gymnasts to do this, just not so good at doing it myself!

Establishing "Core Values"

It was time to get a grip on what we really were about. Our Core Values are based on Empowerment, Partnership, Fair Treatment and Valuing Everyone. From feedback of past members and parents, I felt like these values are based on how we've made our families feel and our relationships with others. It doesn't matter to us where you come from, what colour your skin is, how old you are, how you identify or what abilities you have / don't have. We welcome every single person through our door. Through our sport we have learnt the importance of working together, sourcing external support and learning, teaming up with other sports to enhance our experiences through various projects and ensuring everyone can reach their full potential. Because of this we could no longer commit to "high performance" gymnastics, rather we prefer "high performing" gymnastics with opportunities for a wider range of people.

Telling our story

Success is the accomplishment of an aim or purpose and I feel we have had 22 years full of success with many more to come! We continue to serve our purpose and inspire the next generation of gymnasts, young leaders, and technical coaches. Through our variety of competitive and non-competitive gymnastics programmes for all ages, our Leadership Academy where our teenagers learn about coaching, leadership and

running events, gaining qualifications and giving back to our community and our coaching programmes creating new job opportunities and giving our coaches the experience and tools to be able to coach anywhere in the world, we truly are a "high performing" organisation.

In 2019 we had the most amazing opportunity to represent Great Britain at World Gymnaestrada in Austria. This is the world's largest non-competitive sporting event with more than 22,000 participants. The theme was "come together, show your colours", which you interpret in your own way and demonstrate through a group performance. We were privileged to take a delegation of 27 gymnasts with a wide range of abilities, ages and backgrounds to experience this amazing week of celebrating gymnastics and we did so by performing our version of "A Belfast Story". Through costumes, music, dance and gymnastics we told the story of Belfast. Starting with the Belfast troubles, children wanting to play together but couldn't because of the political and cultural divide, breaking down barriers which restrict our communities and working together to support the peace process, we performed our inspiring routine across 6 cities. The loveliest memory was that of an English woman who was touched so deeply she couldn't stop crying! She said we portrayed it perfectly! This was an empowering moment; for me and my team. A moment of realisation of the impact we have on those around us and how bringing these gymnasts together (from both sides of the community) encompasses every one of our core values.

BIO:

Alison McMullan is Founder and CEO of Abbey Gymnastics CIC, a multi-award-winning gymnastics club in Belfast. She is passionate about her sport, her gymnasts and her coaching team

past, present and future. She has come to accept she has a unique way of working. However, as an essential ingredient in the Abbey recipe of success she continues to work on herself, recognise her strengths, learn from the past, embrace the present and look forward to the future.

www.abbeygymnastics.com

PURPOSE, IMPACT, MAGIC AND CHANGING LIVES

KArima McKenzie-Thomas

Some people get one messed up parent; I got two.

I'll spare you the sordid details of my pop up every few months abusive father; my mother who'd had a horrible relationship with her mother; the abandonment - both emotional and physical; the verbal, physical, emotional and in my teen years sexual abuse; and the consistent upheaval as we moved, moved and moved again a few more times.

Suffice it to say that although there was good physical care from my mother (apart from when she savagely hit me) and there was thankfully much love from other members of my family, by 21 I was a ball of low self worth, anxiety, depression, suicidal thoughts and socially acceptable self harming - which looked like me interacting with men who hurt me in various ways, drinking irresponsibly, and regularly indulging in life threatening activities. I apparently covered it very well though, as from all reports I seemed fine to most people – bubbly, laughing a lot, excelling professionally, and the life of every party.

Also at 21, I walked myself into a 3 year relationship characterized by gross disrespect, financial and emotional abuse, a hospital stay when my body went comatose due to stress, a miscarriage with another hospital stay because I'd lost so much blood, then a pregnancy a few months after that.

But, he never screamed at me or threatened to harm me physically – so that was a massive upgrade on my father, and he never hurt me physically, even during that one time near the end of our living together when he pinned me down on my bed with his 6ft 2" muscular frame, demanding that I have sex with him one last time. Thankfully in that instance a neighbor heard my screams, came running, and banged on our front door til he got up off me and exited our apartment, leaving me a sobbing, shaking mess.

I walked out of that three year saga at 24 with:

- An infant child – whom my mother had 'extracted' months before with a week's notice: "That is not a healthy environment for a child to be in. Please pack my granddaughter's things, I am coming to get her"
- No money to my name, after I'd walked in with thousands of dollars in stocks and more than 10 thousand in savings
- Just my clothing and personal effects, leaving all my furniture, appliances and books behind (Of course I'm the one who furnished the home!)
- Even lower self esteem than I'd had before.

Did I have my come-to-jesus moment of clarity after that? Nah! Of course not!

No, first I found myself in a 1.5 year relationship that became physically and emotionally abusive. He also drove off on me one night and made me walk a ways behind the car trying to get in, and he outright left me at an event far from home another time.

When I left that one I got into a situationship, and in year 2 found myself pregnant. I went in (by myself) for a 7 wks termination - because I was NOT going to be a messed up single mother of two... nope! - and even with all his previous vehement professions of love, Mr. Situationship didn't even call to check up on me that day, nor for 4 days afterwards. Not even a message; radio silence. Thank god for my girlfriends, who closed ranks around me.

Now that I've properly shocked and probably scarred you and you're also possibly judging me, you'll be happy to know . . .

THEN I came to my senses!

After the termination and the callousness with which I was treated by yet another man who claimed to deeply love me – a pattern which had begun with my dear daddy approximately 25 years before - something inside me broke and I realised I could NEVER allow myself to be treated that way again, so . . . I had to fix me.

THAT was when my journey to healing began!

And I went deep. I took on my healing like a degree – books, hours of YouTube learning, articles, journaling, in person Coaching programs – you name it, I did it.

Generational cycles, abuse cycles, trauma cycles, passing down of addictions, symptoms of low self worth, effects of trauma on the nervous system and the psyche, the intersection with money, and on and on. I learned it all, looked at my life, self diagnosed, and did the work.

As I did the work, I shared my Ahas on social media via blogging and facebook, and a funny thing happened. I began to realise that I was touching other women, shifting their perspec-

tives and helping them to do better as well. I began to get feedback that I was inspiring them, that they were thankful for me, and that they looked forward to the wisdom and information I shared.

WOW!

I wish I could say it was in those early years of my work and healing that I also had the revelation I'm about to share, but no. It took me a good 5 to 8 years later, to realise the truth in this statement which I had deeply despised hearing while I was living through all of my pain and dysfunction:

"One day, it will all make sense. One day you will see that it was ALL for a purpose, and you will be grateful".

I remember moments when I would hear one of the "gurus" I was listening to say that, and I'd think it was total BS! I'd get deeply offended and all in my feelings, because who... WHO could be grateful for all the abuse and upheaval and horribleness.... WHO???!! HOW??!!

But in that moment of clarity almost a decade later when it all fell into place, I saw my Purpose. My purpose of helping women to overcome their stuff - their traumas and hurts and fears and limitations - to live lives of unimaginable peace, ease, fun, pleasure, joy and purpose; to live the VIP Life. Just as I had first done for me . . . to save me . . . to save my daughter, I was now being called to do for others.

And that Purpose became my work, and my business. All that pain and all the years of learning and doing and growing, WERE for a Purpose. They were for MY Purpose – VIP Life Success Coaching.

So Luv, it's your turn now:

What's YOUR work? What's YOUR Purpose?

What's the thing that rests deep inside you, that bubbles forth from you into your social media posts and your casual conversations? That thing which you would happily spend

hours on youtube exploring? That thing which you could spend hours experimenting with, and teaching others about? Because.... THAT is your Purpose, and THAT's your business waiting to be born.

And let me help you – although it is magical and seeded into you from The Source itself, your Purpose is not something grand (and it certainly doesn't have to include struggle, trauma or deep pain!).

Far too often we get caught up in wanting the dramatic thing, or that idea that'll reach the masses in all corners of the globe, have crowds screaming our names, and seeing our names in lights, but... that's not Purpose.

Purpose is the One.

Purpose is that loaf of banana bread only you can make as rich and decadent as you make it, which brings moments of desperately needed comfort to a woman who is trapped in a life she doesn't love, but can't escape right now.

Purpose is the woman who will come to you to learn to crochet or knit, so she can make with her own hands and hope and love, a blanket or pair of booties for the baby which will come forth from her first viable pregnancy after 8 miscarriages over the last 10 years.

Purpose is the small family you will counsel and help them to break generational cycles of dysfunction, so their entire future bloodline will be healed.

Purpose is the bedridden older woman who tunes into YouTube every week to have her heart filled with joy, watching you putter about in your garden and love on your plants, under the sunshine.

Purpose is that woman who you will help with her branding, which will massively boost her confidence and make her abso-

lutely in even deeper love with and fired up about, her business and her purpose.

Purpose is the doodle . . . your doodle . . . on their refrigerator, which is the only bonding moment a mother and her estranged teenage daughter share these days, because it makes them both giggle each time they pass by.

In my Purpose, I shift ONE woman at a time during ONE conversation, and I change ONE life at a time through my book "The Make Me Good With Money Book".

Still iffy about the power of the one? Then I refer you to the wisdom – "If you think that one is too small a number to make a difference, try spending the night locked in a room with one mosquito".

Luv, your Purpose is the One. Your purpose is ALWAYS the One.

And if you do it right, you will help that one, then another one and another, and soon . . . you will change the world.

So, it's time to share your magic.

It's time to own and embrace your Purpose.

Start the business.

Take your candle and go light your world, one changed life at a time.

Peace and Light,

BIO:

In 2011 while doing her work – which continues today, KArima 'KAramel' Mckenzie-Thomas also stepped into her Purpose of shifting people towards their best lives.

Since then, the creative, intuitive and informed problem solver and life-altering Speaker/Coach has become known, respected and sought after for delivering her signature Hard truths, Different perspectives and No-nonsense tough love, that

get people Unstuck, Inspired, and Recommitted to themselves and their dreams.

Her mission is 'Breaking chains of generations, by freeing one person at a time, today'.

Have YOU had an encounter of the VIP Life kind?

www.linktr.ee/teamviplife

9

THE PRIVACY NERD

Lizette Van Niekerk

E very time a woman reaches a milestone birthday with a big zero next to it, she'll find thousands of articles telling her what she should feel at that age, how she should look, what she should wear and about the latest creams to rejuvenate her appearance. Very few will tell her to be brave and start a completely new career, especially at 50, when by Hollywood standards you are only good for sad, old lady roles. But that is what I did.

The one thing I can say about my life is that it has been interesting, almost too interesting at times. I was brought up in South Africa in a dusty mining town where I always dreamt of becoming a diplomat. This was a big dream for someone from a community where nobody knew anybody like that. I didn't really know what diplomats did, but I was determined to combine travel with my interest in politics and saw this as a way to do so. When I think back to my 22-year-old self, fresh out of university with a politics degree under my arm and determined

to make it, I'm often astonished at the naïve confidence of youth. How did I not even have a Plan B or C or D?

Diplomatic Years

To everybody's surprise, I was selected for diplomatic training and eventually qualified. It was wonderful, and I felt on top of the world. The country was going through a fundamental transformation and suddenly South Africa was no longer the pariah of the world. I could hardly believe my luck when I got to meet icons of our time like Nelson Mandela and Desmond Tutu. Mandela is still the most impressive person I've ever met; he treated everybody the same and always made you feel special. Things were going as planned, and life seemed destined to turn out exactly as I wanted.

Just before my first posting I married a fellow diplomat, but when we returned it was clear that in the future it would be virtually impossible to be posted to the same country together again. One of us had to give it up and do something else, and we had decided that it would be me. I left the career I loved to start a small franchise business using all my savings.

Then everything came crashing down on an ordinary Friday afternoon three months later. I was approaching one of those milestone birthdays when out of the blue my husband decided he didn't want to be married anymore. Suddenly it was all gone – my home, my career, my savings, and my income. Part of the deal had been that he would support me as my business got off the ground, now all that was gone, and I had to sell at a terrible loss.

New Beginnings

Getting back on my feet was the hardest thing I'd done up to

that point in my life, and it nearly broke me. But I eventually found a wonderful career promoting Canada.

Canadians are some of the warmest and kindest people in the world, and they helped me to regain my confidence and glue all the pieces back together again. On top of that, more than twenty years later they're still some of my best friends.

During this period, I also met the love of my life, and it looked like life was back on track but in a different way. Then we got itchy feet.

My husband's father had also been in the diplomatic service, and he had grown up around the world so loved travelling. We decided to take an overseas adventure to work and travel abroad for a year before mid-life set in completely. We each packed two suitcases and arrived in the UK in 2006 on a bitterly cold December morning. My amazing Canadian employers had given me a leave of absence for a year, and our families were looking after our newly built dreamhouse, so it was all arranged for our return.

But we just never went back.

Our first years in the UK were both wonderful and terrifying. I recall that for the first few weeks on my way to work on the Tube I would allow everybody else to go before me and realised, after eight trains had come and gone, that I was still on the platform. I had to toughen up and learn how to survive in a very competitive and demanding new environment. I realised that although I came from a country with wild animals, it was in London that I was going to get eaten alive unless I developed a much thicker skin and reflected supreme confidence, even if it was just on the outside. To my surprise, I thrived and had wonderful career opportunities.

Politics and Privacy

I've always been interested in politics and eventually became

actively involved, stood for election and won. The first time I saw my own name on a ballot paper the thought crossed my mind that this particular horse was perhaps going to be too much for me. And in a way it was, women in politics really do have a terrible time. Although I did not much enjoy the public side of it, I liked the fact that I could help people to enforce their rights and also found the philosophical side of ideas endlessly fascinating.

It took me back to my student days, and I slowly realised that my main interest was the rights of individuals in society. As the world around us started to be dominated by tech giants who knew virtually everything there is to know about us, I became more interested in the world of privacy and data protection. People have privacy rights, and I felt that we needed to learn how to use them and that companies had to take more responsibility to respect our rights.

I enjoy studying and have been a lifelong student, sitting more exams than I can remember. Just as another milestone birthday started to appear on the horizon, I decided to formally qualify in privacy law and management and to go out on my own to help companies comply with the new complex and diverse data protection legislation. The challenge was that my earlier business failure had dented my confidence, so my husband had to give increasingly more creative pep talks to encourage me to go it alone. It sometimes felt that I had a psychological barrier that kept telling me that I was not businesswoman material.

First Clients

My years as a diplomat had taught me how to "work a room" and to sell my country, but suddenly I had to sell myself – I was the product – and I was petrified. When I showed up to my first networking event I could hardly open my mouth and felt frozen

to the chair. With the help and support of a wonderful group of likeminded women, many of them in this book and in the other volumes, I started to win small clients and found myself never without work. Previous contacts also reached out and asked me to help, and they then recommended me to their clients. Slowly the word got out that there was someone who could help with what most small organisations regarded as a headache that belonged in the "too difficult to deal with" pile. I branded myself as the privacy nerd and tried to get people more interested in the topic generally by sharing my own enthusiasm. It felt good to be able to apply my knowledge and to be intellectually challenged every day because of the complexity of the area I specialise in.

I won my first big client because I was prepared to start a new assignment four days before Christmas. Other consultancies had already closed for the year and didn't want to start a big project when the rest of the world was in the middle of the party season. It taught me a very important business lesson – never say no to an opportunity.

When I showed up for the first day at the impressive corporate address, I was convinced that they would escort me out of the building within a week and imposter syndrome firmly took hold. It was a big step up from my SME clients to a FTSE 100 company, and the expectations were very high and the pace fast.

As it turned out, I was not escorted out of the building but was asked to do more work, and this client eventually introduced me to other big clients. Taking this step up helped to establish my credibility as an expert in my field who could be trusted to solve this headache for companies of any size.

What Next?

I love what I do and am grateful every day that I have this opportunity. Like all businesses, there are good days and a few

awful days. It is hard to keep going when you spend weeks on an assignment and then have to chase endlessly to be paid. The secret I find is to just keep going, sign up for the next networking event, and show up. You never know what opportunity is waiting around the corner.My next focus is to expand my services and to bring more people on board to support my clients. The UK is entering an exciting new era of data management. With new legislation on the horizon and the expansion of technology, the pace is fast, and I need to stay on top of the latest developments. I regard every day as a school day.

When the next big milestone birthday comes along, I hope to look back and celebrate how far I've come, even if, by Hollywood standards, I'll be the female age equivalent of the living-dead by then.

BIO:

Lizette Van Niekerk is the founder of Jarvisfields Limited, a privacy and data protection consultancy specialising in compliance and risk management, staff training and accountability framework implementation. The company offers an outsourced Data Protection Officer (DPO) Service. She works with clients of all sizes and across a range of sectors including SMEs, FSTE 100 companies, charities, and local government councils in the UK and in Europe. She specialises in gap and policy analysis and compliance project implementation.

www.jarvisfields.com

PLEASE, JUST DON'T!

Vanda Varga

I t's 2004, I am in Budapest, Hungary.
After years of struggling with English at school, being one of the worst in my class, I finally got to my A-levels. At the end of the oral exam, my English teacher said to me:

"Vanda, I will give you a good grade to keep your average up, but only if you promise me, that you will never, EVER try to speak English, ever again. Please, just don't!"

After my A-levels, I went to University in Hungary and studied Conductive Education to become a neuro-rehabilitation specialist (called a conductor) and a teacher to work with children and adults with different neurological conditions. This method of rehabilitation is based on neuroplasticity, the brain's ability to rewire itself; so people can create new neural pathways in their brains in order to overcome symptoms of any neurological conditions.

At that point, with this 'lovely' limiting belief in the back of my mind, I joined the club of people who said: "I am useless with languages. I just can't learn English. I will never work

abroad, I will never live abroad, I will just stay in Hungary for the rest of my life!"

Life is a funny thing... At the end of my first year at University, I had an opportunity to work in Hereford and Cornwall during school holidays with a young girl who had Cerebral Palsy.

Even though I didn't want to work abroad and had zero confidence in my language skills, I was pretty desperate for money to be able to support myself and fund my studies. So, I said to myself: 'Ok. I'll go once. I'll see what it's all about. But that's it.'

And thus, my journey began...

I still remember the first time I arrived at Gatwick airport in 2005. I went to the train station. After years of studying English, I got all my knowledge together and built up the courage to ask the lovely gentleman at the ticket office:

'Can I have a ticket to Cornwall, please?' – with the worst Hungarian accent possible.

What surprised me most, was that he understood what I said!

After an 8 hour train ride, I was there in windy Carbis Bay, staying in the home of the girl I was meant to work with for 3 weeks. Not knowing the place, not knowing anyone there. And I was hungry. So, I didn't really have a choice, but to start putting words after each other, and speak. Yes, in English!

I ended up working there for three years. Every Christmas, every Easter and every Summer Holidays while I was completing my BA degree in Hungary.

And each time I was there, I picked up new words, listened to how people were constructing their sentences and would try to repeat them... and slowly became more and more confident...

Every time I was asked to do another block over those three

years, I said to myself: '*Ok. I'll go one more time. And I definitely won't move to England!*'

And then I finished my course at university and graduated with BA Hons in 2008.

After months of trying to figure out what to do next, my dream job appeared! Working as a conductor, with adults with neurological conditions in one of the biggest adults' departments in the world. Yesss!!

But wait! Where is it?? Nice – Centre for Movement Disorders, Birmingham, England...

Oh.

But it was my dream job!! So I said to myself: "*OK. I'll work there for a few months. A year tops!*"

And the few months turned into a few years...

I worked as a conductor where I heavily relied on my language skills amongst other things, so I kept learning and improving my English to be able to do well at work. I socialised with English speakers, read books in English, watched movies and theatre plays in English, did a foundation course in Art Therapy in English, did a MA Module in Mentoring and Practice Tutoring and taught conductor students at the university, in English; studied other things in English, even did a Spanish course in English!

Long story short, in 2016 I completed the Life in the UK test amongst other requirements and became a British Citizen.

And my journey hasn't stopped there...

In the same year I moved down to sunny Hampshire to be in-charge for the Adults' Department of the Rainbow Centre in Fareham. Another dream come true!

Whilst I loved being a conductor, felt that I was born to do that, and thought this was the only way to fulfil my purpose in life, my body didn't really agree with me on that.

I had long-standing back issues. Teaching people to walk and talk after a stroke, teaching people with Parkinson's how to

move around, or facilitating them to transfer from a chair to bed or stand when they have Multiple Sclerosis, Cerebral Palsy or have been paralysed, can be a physically very demanding job at times. But I kept brushing my back problems under the carpet, saying: *'But you love this! And you are young. You can do this. Mind over body...'*

And the more I did that, the more I didn't listen to my own subconscious mind shouting at me through my body, the worse it got.

Up to the point that my subconscious mind had enough and made sure I did stop and listen. My discs in my spine prolapsed and I was bed bound for a while.

I was devastated.

In hindsight, this was a great thing. Because this was the time when I really had to stop, listen and think. Look for something I could do in the future. Something I could transfer my field of expertise into. Something that would give me a new challenge. Something that would still support me in fulfilling my purpose without the physical strain on my body.

And this is when I came across NLP – Neuro-Linguistic Programming. Based on neuroplasticity, the brain's ability to rewire itself. Based on the theory that whatever you put your mind to, you can learn; develop and master new skills and become whatever you would like to become.

Conductive Education and NLP: A match made in heaven!

I went for a foundation weekend in London. Two days of NLP, taught by Toby and Kate McCartney.

A few hours in I felt: *'These people are speaking my language! They are talking to my soul. This is it. I'm home.'*

I didn't need more; I started to study and became a practitioner. Then signed up to a hypnotherapy course with the wonderful Steve Adams. Then I gained a coaching certificate. Then became a Master Practitioner and Trainer of NLP. A Mindfulness practitioner... And it never stops...

After a couple of years of training and practicing besides my job, I decided to leave the comfort of full-time employment and pursue a career in NLP based coaching and Hypnotherapy, as well as teaching NLP as a sole trader.

And boy, did I choose the best time to do that? I gave 4 months' notice and my last day of employment just happened to fall on the 28th February 2020. Yes, two weeks before the first lockdown!

'Vanda! What have you done!?'

But that was it. I had made my choice. I needed to make it work.

So, with my wonderful other half (plus my web and graphic designer, sound engineer, tech and IT support guy, researcher and personal cheerleader all in one), Johannes by my side, I did.

Besides Johannes's support, the other great thing that really helped to elevate my business was networking. As horrifying as it seemed to begin with, I must admit, this was hands down the best thing I could ever have done for my business, and for myself. Being a sole trader can be a very lonely place. And due to networking, I've never felt alone in my business. I've never had a question I didn't have a person to go to with. I've met countless amazing, supportive and inspiring people on the way. And I am very grateful for all the people who believed in me, and all the ones who didn't. You all inspired me to grow in ways I didn't know was possible.

So here I am now. Running my own, successful business. Using English for a living, facilitating wonderful people to transform the way they think, act, communicate and take control over their own lives. I get to help people get rid of their self-limiting beliefs, their fears, anxieties, things that had been holding them back from the past. I get to empower people to become the very best version of themselves and live the life they desire.

And all this in two languages... (And sometimes I think to

myself: I should charge my Hungarian clients double, because it can be so much harder work in Hungarian than in English...).

I give talks and do workshops, encouraging people to take charge of their own happiness. Fulfilling my purpose each and every day.

At the beginning of the year, I even opened my own Training College, so now I get to spread the magic of NLP and the power of your own mind even further. And with each and every course more and more people get to learn and experience that there is always another way. Just because it 'used to be that way', it doesn't mean that it has to be that way in the future. We do have a choice! And most importantly we do have the ability to change. We get to choose how we would like to wire our brain! We get to choose how we live our lives.

Let's look back at 2004...

"Vanda, I will give you a good grade, but promise me that you will never EVER try to speak English, ever again. Please, just don't!"

Well, Miss, I didn't try. I just did.

The message I would like you to take away from my story is that You Can!

Dream big. Never let anyone put you down. No matter who it is, no matter what they say.

Believe in yourself, and do it anyway. Remember, there is no failure, only feedback. You can either succeed or learn. You have the ability and all the resources you need to succeed, and it's all within You.

And no matter what you do, never ever allow anyone to tell you what you can or can't do!

Please, just don't.

BIO:

Vanda Varga is a Trainer and Master Practitioner of NLP and Hypnotherapy.

She is on a mission to help people, like you, who are committed to making a change, explore their inner excellence and become the very best version of themselves; guiding them on their journey of self-enablement to grow in confidence and self-esteem and lead a purposeful, proactive and fulfilled life.

She is a firm believer in people's potential and life-long learning, knowing that everyone learns differently, therefore everyone's growth will look different too.

https://vandavarga.co.uk/

FROM CORPORATE TO CAMPO

Nicola Toner

Bombs on buses and tubes, that I missed by a day. Motorway pile ups, that on numerous occasions I would see as I crawled past. Colleagues dropping like flies with depression and literally just vanishing from the company. This all became normal in my corporate life. I lived continually with the anxiety of never finishing anything I started, not always down to my own fault, but always feeling like you have missed something, someone was waiting for something, was there a deadline you have sailed past oblivious, isn't a good way to live, mentally or physically.

I've always believed that sales is just a numbers game, but so are a lot of things. I am a self-confessed process-junkie, I love to be driven by the steps of a process, I like order and calm and to see progress in the things that I do.

Being in topflight national sales meant I used to spend hours in the car, at a desk, then back into the car again. Don't get me wrong, it was a really nice car, but you don't know what type of car it is when you're on the M6 in the dark at 10pm on a Friday

night, stand still traffic and still an hour and a half to go before you collapse into bed with no dinner, because you know there's nothing in the fridge because you've been away since Sunday. My long days and commitment to meeting my daily work objectives was generally overlooked. I always lived further away from clients than my colleagues, or further away from head office. I remember leaving the office in Borehamwood on a Friday at 4pm, feeling like I was not pulling my weight, but faced with a 5 hour drive and wanting to beat a little of the rush hour to get on the M1 before 5pm and the receptionist looking at her watch and saying "oh, you're having an early dart, must be nice to finish early". My response was not pretty or even repeatable, but she never made that assumption again.

The work hard, play hard culture of being a "team player" with a boss that calls you "the rockstar" because you're hitting your targets like a championship darts player, making you look fantastic and him look like God, is addictive, but it really does have a price.

Saturday morning guilt, knowing there were 101 unfinished jobs around the house, but you are so tired and, in a fuzz, because the entire bottle of wine you drank last night to bring you some sense of relaxation is fogging your head and making your downtime an uphill struggle. This was a hamster wheel. There must be a better way, surely?

Then one Saturday, the dynamic changed. I'd managed to get myself up, put on old clothes and I was going to paint my garden fence. I like a project and the 6ft fence, around 3 sides of my garden, was this week's attempt to improve my surroundings. I'd luckily found myself on a retail park during the previous week, visiting a client's outlet, and had whizzed into B&Q to load myself up with the fence paint and some brushes. I was going to spend my Saturday doing something I had put off for weeks. I was looking forward to the long day of physical

labour and the sense of achievement on Sunday as I stood back to admire my handywork.

It seems the universe had other plans as three hours in I crouched to reach the bottom of a panel and then couldn't get back up. The previously ignored back twinge from sitting in my car too often had turned into an all-out excruciating pain that made any movement impossible. I remember lying on the grass thinking that I was just going to die there. It took me a few minutes to realise I was crying and that really shocked me, even more than the fact that every time I moved, I felt that my legs were being ripped from my body. In an attempt to switch off, I'd left my Blackberry in the kitchen, the neighbours were away on holiday and the dog was just looking at me as if to say "it serves you right for not taking me for a walk".

I finally managed to sob and cry and crawl into the house, it felt like it took me hours, on all fours going along the hallway, up the stairs, along the landing, into my bedroom and on to the bed. My first thought was to be worried about work, what if I was not fit to get back in the car tomorrow and drive to wherever I was supposed to be going? I had a meeting on Monday for god's sake! I am the person who is never sick. Would they believe me, would my boss be annoyed? Was I letting everyone down?

I missed the Monday meeting. In fact, I missed a lot of meetings. For three weeks I just lay there, with the first two and a half feeling almost paralysed. My boss had been sympathetic at first, sent me flowers (did he not realise that I couldn't get up to answer the door to the florist?) but by the end of week two I could hear the irritation in his voice. I was tentatively up and about, I had been for a walk so felt the worst was behind me, but the immobility had given me time to think, a lot. I needed to find that elusive better way.

I called my boss on the Friday of the third week to let him know that I would be attempting to get back to my laptop the

following Monday and instantly felt that he was strange and cool with me, a totally new experience. I look back now, and I think he was talking advice from HR and they were expecting an absent employee on a vast salary with a BMW on a lease on the drive and nothing they could do until I was ready, it made me very anxious, it pushed me into probably going back to my desk before I should have. I spent time explaining that I needed to adjust the way I was working, not spend so much time in my car, maybe take the train when I needed to get to a city, get home a little more often and find a way to fit in some exercise.

His stilted reply was to ask me to come to meet him at a depot where he had a meeting the following Monday so that we could "have an hour" and he seemed shocked when I declined. I remember his tone when I pointed out that the depot he wanted me to drive to would mean a 6 hour round trip and it was exactly this type of pointless journey that had put me on my back in the first place. He was not, to use his own phrase, "a happy bunny", but he conceded that maybe I had a point. I felt the chill of suddenly falling from the position of Rockstar to stagehand, and it scared me.

We agreed that for the coming week I would just get back on my laptop and work from home. This was allowed as this was the basis of my contract to be home or field based, but my skill had always been to be visible, to be with my customers, on their premises, in their business. One of my most prestigious clients gave me a desk in their office for when I needed to work on projects with them. This new "home-based Nicola" was going to be a shock to everyone, including me.

I spent the weekend in a state of panic. What was I going to do? The seed had been planted, the thing I needed to do was going to be life changing. In my head I was continually asking if there was a better way.

Fast forward 8 months and I was sitting in the Emirates

departure lounge at Manchester Airport, sipping a glass of wine and waiting for a flight to Dubai.

How did I do it?

I simply decided enough was enough. The week I went back to work I had a moment of clarity, I handed in my notice, with the comfort of having a 3-month notice period to work through, hopefully the company would put me on "gardening leave" which meant I could sit at home and still get paid, but hand back the laptop and phone, meaning I would be 100% outside the company loop.

This was a "punishment" reserved for employees who were leaving to usually go to a competitor, but also for those who may know a little too much about the company or its structure and processes to be left in a position to converse with clients or competitors. Unfortunately I wasn't a threat, they wanted me to work to the bitter end.

I managed to negotiate my way out of this and during the downtime I then evaluated what I really wanted to do. How I wanted my new working day to look. I knew for a fact that I didn't want to be stuck in a car in the same way I had been, and this became my sole criteria. The new job mustn't involve national accounts or driving from one end of the country to the other on a weekly basis.

Becoming self-employed was a little by accident, but it worked well. It was a chance conversation with a former colleague, instigated because I had needed to give people a new number and his complete inability to believe that I would leave a really good job without having a new one to roll into, so he called me to see if I was losing my mind. He offered me an interim role while I decided what was next and this led me to start looking at how I could become self-employed or work on a contract basis. The magic project manager words were uttered and off I went to enrol in a course to qualify. Suddenly every job I would do would have a start point, an end point and I could

feel a little more in control of the way my working day looked. I covered the interim role for six months and also looked for my next contract. This turned out to be another six months project but this was an international role in the UAE. So, I was swapping the car travel all over the UK to a plane journey and a very small stomping ground in the city of Dubai.

I had to look it up on a map when it was first mentioned, I wasn't really sure where it was, but it is the best thing I ever did. The six months rolled into just over a year and it gave me the real bug for travelling internationally with my work. I got back to the UK and immediately started to look for the next contract and I can honestly say that it's taken me all over the world, I've worked on long term projects in Cape Verde, in Panama, in the USA several times, Gibraltar and Malta as well as shorter projects in many cities around Europe.

In 2015 I realised that I didn't need to be in the UK to go to work. It didn't really matter what my starting point was, most of the work involved getting on a plane. This realisation gave me the incentive to leave the UK for warmer weather and since 2016 I have lived in the amazing Province of Granada, in Spain, in a beautiful house in the campo with a swimming pool and views over the olive groves to the Alhambra Palace.

I still work hard; I still have the third bedroom converted to a home office and I still make sure that I am up and at my desk every day. It feels like my body told me that it had had enough, and it was 100% right. I found a better way, a much easier way to work and some days I would love to thank my old boss for being less than understanding and making me feel unhappy enough to create the massive change that I needed.

My life is unrecognisable to the way I lived and worked for 20 years. Who would have thought that painting the garden fence could have had such a massive impact? I think I may go and paint something now, just to see if that triggers the next chapter.

BIO:

Nicola Toner has a 25+ year career working for companies like Twinings, Douwe Egberts and the Sara Lee Corp and managed clients like John Lewis, Roadchef and BHS. For the last 13 years she has been self employed as a consultant and worked all over the world, from Dubai to Indiana. Did you know that a business with a proper plan, that actively tracks its business against the plan will grow 30% faster than a business without a plan? Nicola helps small businesses with no business or marketing planning experience. No "get rich quick" schemes without substance here, just a marketing and business degree and a lot of experience and a strong background in getting results.

www.nicolatoner.com

12

NOT QUITE RAGS TO RICHES -
PERHAPS THE REVERSE

Lara Duncan

L et me first introduce myself, I am Lara Duncan and I am a fused glass artist based in Bishop's Waltham, Hampshire. Yes, I **AM** an artist….I keep having to tell myself that because in the past 30 + years I've spent most of my life sitting behind a desk answering to someone else. Even when I had my own successful business for 18 years (more of that below) I had to doff my cap to my Client.

I grew up in a very traditional working class background. My Dad was a self employed Builder and Mum was a house-wife. I was the middle child of 3. I wasn't remarkable in any real way…no real talent to speak of. I glided through school…not over or under achieving…decidedly average.

I left school at 16 and went straight to work and I mean that literally. I finished on a Wednesday or Thursday and I started the following Monday. My friends were all staying on to do A levels but my parents bluntly told me I wasn't clever enough…(I know! Who says those things to a child!) No one quite knows how I got this job, but the Careers Office rang

and an interview had been arranged at a Public Relations firm.

A year on, I was totally bored licking stamps and generally filing. I applied for a job at the counter of The Post Office which I got and stayed there for 8 1/2 years...Met my husband (snogging behind the counter and more elsewhere !!) then I took redundancy after I was sexually harassed at work by an older man. Then a series of interim jobs in offices which I didn't like very much...in a lettings agency; a car auction house and a bit of part time work cleaning and selling advertising. I then started working for Northern Rock after 'leaving' the lettings agency. I stupidly told someone I was going to have fertility treatment and almost the next day I was gone.

Northern Rock was cool...I started as a Cashier at the counter and then started selling mortgages. Moving house from SW20 in London to Hampshire, I then got a job selling mortgages at Lloyds TSB...yeah, hated that! Then worked at a big firm of solicitors in Portsmouth handling calls from potential clients for conveyancing. I was sending out quotes and literature. Do you see a pattern forming? Property?

This was all becoming rather boring so I left to work as a Manager... at a large supermarket chain. Yep, that's right. How MAD was I, and how stupid were they to think I was suited to retail. I had a really hard time there and hated every moment of it. I resigned after 3 months when they told me I had to discipline a lady who had been in hospital with meningitis. And I would be disciplined if I didn't do it....

Temping for a bit, I then saw a tiny job ad in the Portsmouth News. It sounded right up my street. Did I know about financial services? Tick! Did I know about conveyancing? Tick! Did I know about lettings? Tick! Little did I know that I'd just got a job with one of TV's Secret Millionaires!

I was working on a self employed basis on a Helpdesk for people who had been on property investment training courses.

Yes, re-read that. There are companies who sell property investment training and I was the 'expert' on the end of the phone.

I've worked out that to be an 'expert', all you need is to be one step ahead of those you are speaking to.

The property training company sold 'students' (punters) a 3 day basic training for a fairly small price, giving a basic level of information but then teasing them with the opportunity to learn more advanced levels of investment...this costing between £10k-£30K. This would include a 3 day one to one mentoring session with an experienced investor. The advanced training included learning techniques such as Buy To Let; Distressed Property; Lease Options; Commercial Letting; Lease Splitting; Creative Financing....and when I say Creative Financing, I mean buying property using other people's money. Yep, you read that right....and people do this every single day.

And then one day, the Secret Millionaire got fired. I stepped up with a business plan, and took over the contract.

And at exactly the same time I split up with my husband. We had grown apart when no babies arrived. We wanted different things from life. I was meeting people who had exciting lives because they had money from property investment, where we seemed to be stuck in a cycle of living hand to mouth.

My little business grew quite quickly, taking on more work from the main Client to include diary bookings for the Mentors. I took on staff which was such a massive learning curve. Hiring and firing was not easy and I was burnt a couple of times by staff who just weren't the right fit. I don't know about anyone else, but having to fire someone is one of the hardest things I've ever done and it was never an easy decision.

During these early days I took a few craft courses including jewellery making. I loved looking at beads and then making them up into funky jewellery which I had also started to sell on Etsy. Etsy is now a HUGE marketplace but back in the early 2000's it was still relatively small and you could easily start up a

shop. But to stand out, you needed to be unique.....so how about making your own beads?

A friend and I went on a glass bead making course. That's melting glass rods in a flame around a steel mandrel which isn't much of a hop and a step into glass fusing which is where I went onto. I took a class, and then another and within a few weeks I'd ordered a kiln. It sat in my garage for a month before I fired it up, as I was absolutely terrified of it! I mean, what can happen in a fireproof box that reaches 800C?! That's four times as hot as your standard oven.

I'm a great believer that when you start a new skill, it doesn't matter what craft it is, it takes about 2 years before you can make anything of any real substance. And this very much applies to glass. I made a lot of ugly glass, which at the time I was immensely proud of. I made lots of jewellery which I added to my Etsy shop, and it sold quite well, along with panels and dishes. But certainly nothing to set the world on fire.

Back in the day job I was working hard and my income was staggeringly high for someone who had never really had any money. The job in itself wasn't exciting but I'd surrounded myself with staff who I counted as friends and who I trusted. The day job was funding my glass addiction and allowing me to take Masterclasses from the big names in glass fusing. I travelled within the UK taking courses from Amanda Simmons; Alicia Lomne; Craig Mitchell-Smith to name just a few but also allowed me to travel to Florida for tuition with Tanya Veit and to Texas to meet a fellow glassie and swap ideas. My growth as a Glass Artist was off the scale at this point. Glass making is a rule driven art but the real magic happens when you understand enough to know how to manipulate the rules and teeter on the edge of breaking them.

I decided to start to step back from the business in May 2018 to allow myself time to develop as a Glass Artist. I had just turned 50 in Hawaii, had a new husband and life was great.

In December 2018 my older brother suddenly died from SUDEP (sudden death from Epilepsy). We had just moved 6 days earlier to a rented house whilst waiting for our dream house to be built. This isn't really the place to discuss my grief but I took it very hard and I'm not really sure how my husband was able to cope with me. I hated everything but especially the rental house and it seemed to symbolise everything bad that was happening in my life. The reality was that it was quite nice. I was drinking quite heavily. My weight soared and I was desperately unhappy. Life stuttered forward and in October 2019 we moved to the dream house.

And then the another body blow, my Client called in November 2019 to tell me that they had taken their business into Administration. I was, and still am in 2021 owed £97k. After telling me this news, the Client asked me to join a new business with him but I decided it was too big a risk to take, and with a very heavy heart I went into my office and made my staff redundant. There are no words to explain how horrific that is. In January 2020 I decided I was going to become a full time Glass Artist. Yay, my dream come true!....Well we all know the next part of the story. With Covid 19 and the pandemic, 2020 became the Year of cancellation. Every single event I had booked fell. It was another body blow coming so soon after everything else. But what could I do but move forward?

Business teaches you to change and adapt, because if you can't adapt then you fail. I had taken the plunge and by God I was going to give it my best shot. Facebook became my new best friend and I started 'going live'. Yeah, that completely scared me to death. Speaking to the World via my phone and selling my wares. But people came to my online events and bought my things. Not in droves, but I steadily set about making it a regular event. I stood in my kitchen, surrounded by glass just talking to an audience around the world….and they loved it and me.

The pandemic also gave me time to think, experiment and explore. A chance to decide what I wanted to do. I taught myself to make murrini which I now sell to other glass makers.I've learnt that I can survive. I am strong and I am resilient, whatever life throws at me. I cry, and then I pull on my big girls' pants and carry on, because you have to. I am nobody's idea of a dream employee anymore. I'm too old at 53 to get that dream job and no one is going to give me an opportunity even though I have a bucket full of experience....so I'm doing this for me. I'm in charge of me and what happens. Am I going to make the six figure salary like before? No, but it's fun, and mad, and scary!....And I love it! I put my heart and soul into every piece of glass I make. Each piece has a piece of me embedded into it. My energy, my love which I pass on to others who own my work and others who come and have workshops with me.

I continue to learn about glass and more importantly, myself. I never stop learning.

BIO:

Lara Duncan from Lara Duncan Glass is a Fused Glass Artist based in Bishops Waltham, Hampshire.

Lara has been working with glass for over 12 years and is heavily influenced by the beauty of her surroundings, the Hampshire landscape. She is fortunate to live opposite the protected oaks of the Pilgrims Path. Her work is a direct response to the emotions she feels to her given subject.

Lara creates glass splashbacks; large panels; giftware; jewellery including Memorial Jewellery; landscape art pieces and trinkets all available directly from her. Lara loves to take commissions.

www.laraduncanglass.com

13

BURNOUT TO MENTAL HEALTH
ADVOCATE

Justine Markley

I began my journey in the corporate world where it was all about 'success' and competition. It dawned on me quite quickly how much this was impacting my physical and mental health. I would wake up at 6am, get dressed, travel to London, be in the office by 7.30/8 and work through until it was dark just in an attempt to prove I could be successful and tell myself I had finally 'made it' in life; because I worked in the big smoke for one of the largest banks in the world.

Success ran in the family, it was something I wanted to obtain but the route I was heading; wasn't what I had in mind. I had become lost and felt I needed a new focus to find myself again. I was getting bullied at work - being told I wasn't good enough no matter how hard I tried. I felt worthless and wanted to give up. I was experiencing anxiety, frustration; feeling over-whelmed and felt sadness on a day to day basis. I did not want to feel this way but was unsure what was really causing it. I saw my doctor and he advised 'I needed to leave my job'.

I started to focus weekly, which then became daily on ways

to deal with my emotions - stress primarily and the pressure I was under. I needed to find a way to help me to get some balance back. I looked online at self-help blogs, attended yoga, the gym and started to notice quite rapidly that my mind-set, my approach and physical health improved.

I had noticed that I wasn't feeling myself but had not realised how my emotions had spiralled into a downwards slope and that I had lost myself in the process. Day by day, I felt things got better as I focused on my needs. I was more motivated, focused and able to manage my workload and personal life. But something was still missing. I was still feeling flat and unable to be my bubbly self.

I took a lot of time to reflect on myself, my social circles, my job and saw that I needed to look at what it was that made my heart sing and set my soul on fire and the job I was doing wasn't the one. I started to see that I really felt content when I was helping others. I began mentoring colleagues at work who wanted my help and volunteered outside of work. I was drawn to organisations that focused on mental health so decided to volunteer at my local community centre and I made the decision to leave my job even though I had nothing to go to.

I was ready to take a leap of faith and trust that my needs would be met and focused on cutting out negativity, social circles that didn't align with my true self and I started networking to get myself out there. This is where my life changed. I realised I was destined for helping others in some way connected to mental health but wasn't sure how this would happen. I recognised I had gone through years of being burnt out and had struggled with anxiety. I wanted to use these learnings to help others going through the same.

Once I started volunteering, opportunities opened up. I got a new job in the NHS, I met a new network of people and started shining my light to help others. It was a lengthy process. I needed to heal myself first in order to start helping others

professionally, so I decided to train as an NLP (Neuro Linguistic Programming) coach and Life coach. I learnt meditation, mindfulness and anything that helped me with all the anxiety I had experienced. I knew I had work to do on myself because I was still feeling the aftermath of the burnout from the bank.

Soon enough, I saw radical changes within myself. I was more aware, calmer and much more at peace day to day. I still had ups and downs but I worked out how to manage them. Then I discovered positive affirmations. These changed my life. I learnt new positive statements that I repeated daily, throughout the day for at least 21 days. My mind-set shifted. I felt so much better and more myself.

Once I had embedded the art of stillness through meditation, positive affirmations and healed past traumas by having coaching, I was in a position to pass it on so I decided to set up my own business and called it 'Believe You Deserve It, Believe In You' because this reflected my journey of just needing to 'believe in myself' to find my purpose and know my worth.

I transitioned and transformed dramatically from working on my mental health. I had learnt so much along the way and really understood my needs, what I need to let go of and how to do it through Holistic learnings, professional teachings and self-help alongside self-care. My wellbeing mattered and I had put that aside in the bank due to lack of awareness and chasing something I knew wasn't right for me.

Life has taught me, no matter what you go through and how hard things can get, it's about changing your perspectives and asking yourself 'what is this trying to teach me?' in order to approach hurdles and successfully overcome them. Taking the time out in your day to reflect, pause and even journal how you feel and what it is that is causing you to not feel yourself are all key elements to bring you back in alignment with who you really are.

Sharing my experiences and stories as well as taking risks (leaps of faith) and being totally vulnerable by telling my truth and exposing the struggles I have been through, in the hope of helping others who are experiencing the same; has not only healed me, but has changed the lives of those I have met and who have become clients of my business. Never be afraid to tell others your battles for they may help and inspire others to do the same!

BIO:

Justine is a Mental Health and Wellbeing certified NLP coach who specialises in anxiety/stress and burnout. She has a strong focus on using Holistic therapy and implementing Positive wellbeing strategies to help clients with overcoming adverse emotions and finding their true self and purpose. Justine helps women who work, women in business and mums to harness the power of their emotions and feel empowered to create the life they want. She is also a qualified Holistic healer in Reiki therapy.

Justine has discovered how using wellbeing practices and fully understanding yourself and your triggers can help eliminate anxiety, stress and also work related pressures that lead to burnout. She works with individuals 1:1, the charity MIND, multiple organisations and community groups to bring a better way of feeling and living through Holistic Wellbeing workshops.

www.linktr.ee/jmarkleybelieveinyou

14

"YOU'RE NOT GOOD ENOUGH"

Nisha Haq

That's a phrase I've often told myself.
It has stemmed from years of accepting people with 'more authority' than me and all the micro-aggressions I'd experienced and accumulated in my head.

One particular experience that has stayed with me was when a family friend, an older white man and retired lecturer said these four words to me, "**your business will fail**". The reason this had impacted me so much was the mental state I was in at that time and the type of person telling me what I wasn't capable of.

When those four words were directed at me, I had just graduated from Solent University with a Photography degree. The business I wanted to start was a photography business.

I had just moved back to my dad's home after three years of independent living in Southampton city and readjusting to living with my parents again. It was a tumultuous time with this new living situation, let alone feeling like a failure that I was

unemployed, on benefits and being rejected from the few job opportunities available.

Only a few months prior to those four words being said, I had received £2,000 investment from Solent University under their entrepreneurial programme for new start-ups. I was in my final year with only a few months left before finishing my course.

I didn't know what job I wanted to get straight after being a student but knew my end goal was to have my own successful photography business that would earn a decent living. My thinking was 20 or so years in the future, but eventually that would be the dream.

On the last day of accepting applications, I tentatively submitted my business proposal. I thought to myself, 'What have I got to lose if I don't apply?' If anything, it would be an experience to learn from.

I was invited into a small room, a long table separating me from the judging panel. My heart was racing knowing I had to stand up and give a convincing pitch. This was the first time ever giving a business presentation. It was a strange feeling having to prove to strangers why I was good enough to receive this start-up funding. It was like I was in 'Dragon's Den'!

It was an agonising few weeks of the judges deliberating whether my business idea was good enough for investment. I had originally pitched for £1,000 but to my surprise, they offered me double! I remember being in utter shock.

This was the first time I felt someone truly believed in my business and me as a businesswoman.

Fast-forward a few months later when the family friend told me my business would fail, in that moment, I did feel like a failure. I felt so deflated. I felt no one believed I could actually start my own business. How quickly I went from being confident in myself to feeling so little.

No one in my family was entrepreneurial, the thinking was

to get a job, work your way up the company and you'd be sorted. I was explaining how that wasn't really the case for photography as many professionals are freelancers and the job market had changed a lot for the millennial generation.

It stung hearing those words, especially from someone I thought would be supportive. But in that moment, I believed it. I felt powerless, being a young Asian female, who was I to set up a successful photography business? Where I lived, you didn't see successful young Asian creative female business owners, why would I be any different?

I knew being in this environment wasn't doing me any good. My confidence and mental wellbeing took a beating and the longer I stayed, the quicker my dreams and passion would fade away.

I was fortunate to get a new full-time job at the same University I graduated from, in their Employability and Enterprise department (the same department that ran the start-up funding that I'd received). This was my ticket to going onwards and upwards. I moved back to Southampton City and away from the negative environment I was living in. I remember getting my first paycheck, I felt like a 'proper adult'.

My confidence significantly improved, I was living independently, making my own decisions. I felt I was working closer to my eventual goal... having my own full-time successful photography business.

After the graduate scheme finished, I felt it was time to just go for it and register my business name, Nisha Haq Photography. Even if I was just making small amounts of income, I now had a business I could call my own. Using my start-up funding from Solent University as well as receiving additional investment from Solent LEP for young entrepreneurs, it was definitely my time to start.

That same month, I started a new job as a Graphic Designer and Communications Assistant at a local housing association. I

was now working in a creative capacity and in the marketing team. I was working my way up!

Mentally I felt in a good place, I was earning some money from photographing weddings on the weekends and I was building more contacts, referrals and organically growing the business in my spare time. It wasn't a full-time salary to live off just yet but I knew I was starting something special.

After a year in my second employed job I moved on to working as a Graphic Designer and Marketing Officer at an opera house. My salary significantly jumped and I was excited to be working my way up in the creative industry. It was a tough interview process so I felt even more of an achievement to get this position. I remember being particularly enthusiastic as the CEO was an experienced strong independent Asian business woman in a male-dominated industry. I felt I could learn so much working in her company and be motivated to do my best everyday.

Unfortunately, that wasn't the case. I was made to feel, yet again, not good enough. In this case, feeling like 'the help' and not valued in my creative ability and being constantly micromanaged in everything I did. Simply not feeling valued as a person, let alone my contributions to the company.

It got so bad to the point where my heart-rate accelerated whenever I'd see the CEO's car parked at the office for an impromptu visit. That awful feeling of dread having to see her in person.

One time she yelled at me so much through the phone that I cried. I had never cried in front of my colleagues before. I was taught it was a sign of weakness and you shouldn't show this kind of emotion in the workplace. I had worked so hard putting up protective armour so people wouldn't see how badly I was affected but this time was just too much.

Looking back, I hadn't realised how damaged my wellbeing

was and that vision of running my own business full-time felt near impossible at this point. I felt defeated.

Though feeling at my lowest, I remembered a flyer I saw when I worked at Solent University for applications for the IPSE (The Association of Independent Professionals and the Self-Employed) Freelancer of the Year Awards. There was still a glimmer in me wanting to make a name for myself. I knew I couldn't work in employment if I were to continue being treated like I wasn't good enough.

The deadline for this prestigious nationwide industry awards was looming. Again, I thought to myself 'What have I got to lose?'.

I mustered enough motivation to submit my application for the under 23's category on the last day of entry and to see where it took me. After all, I'd be 'too old' to apply the year after so it was now or never!

A few weeks had passed and I was stuck in the same routine of commuting to a job I dreaded everyday. One morning I woke up to an email that read 'You have made it into the final 5 for the IPSE Freelancer Awards'. I was ecstatic! I was starting to believe in myself again.

It was a cloudy April day in London and I was trying to keep my nerves under control throughout the 2-hour train journey up. I had triple-checked that I had my presentation cards with me, my sample wedding albums and products I'd made for my clients to show the scope of what I offered in my business to the judges. I knew my clients valued me and the heartfelt comments and thank you cards I'd received. I knew I was making a difference in some small way.

I had delivered my pitch and did the best I could do. I felt proud I had done it, whatever the outcome. It was down to the judges to decide.

Two months after the pitch was the glitzy awards ceremony in

King's Place, London. I'd never been to an awards ceremony before so I was excited about the whole event meeting industry leaders and networking with fellow freelancers from all walks of life.

Despite this, I was very hesitant to go. It was the same night as opening night of the opera season and everyone at work was expected to be in the office doing their job; no excuses. Even being shortlisted in the UK top 5 freelancers, I still felt not good enough. The likelihood of me winning was so slim, I didn't really need to attend.

After a pep talk from my housemate and my partner, I mustered the courage to ask for a day's leave at work and attend the awards ceremony. I'm so pleased I did...

"And the winner is... Nisha Haq!"

The audience cheered with a loud applause. I was in complete shock.

I had just won UK Young Freelancer of the Year.

In that moment I truly felt on top of the world. A young Asian female business woman was on the stage receiving an award for her successful photography business.

In the space of three years of an older white retired male lecturer saying "your business will fail" to being recognised in a leading industry awards on being young freelancer of the year was a 'pinch me' moment.

I was asked on stage (by the wonderful feminist comedian Ellie Taylor) under the bright lights whilst holding my awards trophy, "So what's next for you?"

Being so astonished by this whole whirlwind experience, I announced on stage in front of 200 or so industry peers...

"I'm going to go full-time with my photography business!"

And that was it. I'd said it out loud at one of the biggest free-lancer events, there was no going back now!

A month later, I did exactly that. I quit full-time employ-ment, said goodbye to awful commutes, that feeling of dread

COMPILED BY TRUDY SIMMONS

everyday and shedding that broken non-confident version of me.

I said yes to being a strong independent determined passionate uplifted joyful version of me.

I took the plunge to go full-time with my successful photography business. A dream I didn't need to wait 20 years or so to accomplish.

Because instead I told myself 'I am good enough.'

BIO:

Nisha Haq is an award-winning multiple business owner. She started her entrepreneurial journey with Nisha Haq Photography, a luxury wedding photography brand and launched her second business in lockdown, Iggy & Lime, offering vibrant commercial & event photography.

With over 6 years in business she has photographed over 100 weddings and businesses as well as public speaking at leading universities in the UK.

A year after going full-time self-employed, Nisha was conferred an Honorary Degree from Solent University, the youngest and only a handful of Asian women to do so. She continues to advocate for more entrepreneurial education, especially for young females and more diverse representation in business so that anyone can achieve their goals.

www.iggyandlime.co.uk

15

THE BOTOX EFFECT

Jo Mifsud

S o, if I've understood it right, the brief is, 'write a chapter
about your business journey as if you're talking to a friend'.
OK, so if this is the case my introductory sentence would prob-
ably be something along the lines of "...Oh my god, you will
never guess what happened today, open the wine and don't tell
me how many calories are in this chocolate cake." I don't think
it's the done thing to add emojis into a book but if it was, at this
point in a text conversation it would probably be the one with
the lopsided face and a wobbly smile with the tongue half out
that looks like it definitely needs some face augmentation.

I am Jo, a registered social worker and owner of a care
company for children with disabilities and complex healthcare
needs that I set up 14 years ago. My journey since then has been
both truly fulfilling and quite unexpected!

Being a mum of two and running my own business has been
an experience, and I've learned a lot along the way. I've found
that even the best contingency plans can't prepare for some of
the eventualities that hit a small business. One night you're

sitting holding a sick bucket for a poorly child, and the next day you need matchsticks to try to keep your eyes open through a 10-hour tax inspection. And of course, Covid-19 hit us all in different ways. On one hand I feel so grateful that I was able to remain open, while on the other, the stresses around sourcing PPE for my care workers and making emergency protocols for our clinically vulnerable clients certainly activated the proactive decision-making part of my personality type (according to one of those Myers Briggs type personality things). I needed a change. Or, if not a change, something complementary to everything I had built so far.

Building a partnership

Since my care company is doing well and being beautifully managed by a great team, I've been able to focus some of my attentions elsewhere and look to use my skills caring for the community to start something new. In 2021, I created a new venture with my lovely business partner Kellie. Kellie and I have been work colleagues for over 16 years. Kellie has a nursing background and has been practising aesthetics for many years. During our second lockdown last year, Kellie knew that she was ready to expand what she had learnt, and I was there to be part of the adventure. So, in a nutshell here is my journey into the world of aesthetics.

I've always been in the business of caring for people. Sometimes it's really obvious what people need, like help with everyday tasks. But sometimes the care you need is hidden away – something personal that's much more about your self-esteem than the actual basics of eating or washing and so on. So I've been drawn to helping people, and this next step I took with Kellie started from that point: a desire to help.

I've always had those two lines between my eyes when I frown, and I've since been told that these are in fact what we

call our "11s" in the aesthetics industry. What I've also learnt is that reducing the depth of those lines can boost self-esteem and even in some cases help with more serious issues like anxiety and depression. I challenged Kellie that if she could erase my "11s" I would be sold as a business partner; and so she did!

I've been a sole owner of a business for 14 years, and it can be quite lonely, so it's really lovely to be joint owners with Kellie of our new venture Pallant Aesthetics Clinic for Medical Professionals. The medical professional strapline bit is really important – but more on that later.

My background in establishing contracts in the healthcare world and gaining CQC registrations seemed to work hand in hand with Kellie's hands-on expertise in the aesthetics arena, making it a promising partnership. So, we put a business plan together and had a session with our wonderful accountant, Sarah Shearer at Emmaus accountants in Farnborough.

Clinical training

After our extensive market research, we knew what people were looking for in an aesthetics clinic. Not just a clinic that cared about what you look like, but also how you feel, and most importantly for you to know you are in the hands of trained medical professionals. We offer a unique experience we call clinical luxury, a clinically safe and reassuring environment. We have every certificate and accreditation, which goes beyond other clinics we have come across who often have very junior staff with no clinical training.

Needless to say, I'm not the medical practitioner in the business, that's Kellie. But when we were doing the market research for the business, we realised just how many people doing these invasive procedures weren't trained or qualified to a nurse level. The timing of our opening seemed to coincide with documentaries exposing the lack of medical training of people who call

themselves aesthetic practitioners, and this really gave us the message that we need to make a commitment to be very clear we will only employ medical professionals. So that's where the strapline came from. We want people to know straight away that it's a professional clinic they can trust.

While the world was in turmoil and locked down, Kellie worked relentlessly in the hospitals and then as a nurse lead at the local covid vaccination centre injecting up to 300 people a day. So, we can safely say she is an experienced injector, health care practitioner and all round good person! Someone that our customers can put their trust in. And if you meet Kellie, you'll know she has this super-reassuring manner that puts you at ease.

My sister keeps telling me to sell the light not the lightbulb. After the process of writing and then re-writing content, I think I finally realise what she means. Botox is the lightbulb, but Kellie is the light. Her skills, expertise and experience alongside her calming and warm personality is what people want to come back for. That, and how they look and feel afterwards, reflecting their own light! I would love for more people to join our small team in time, but their experience and qualifications will need to be in line with our values.

Calling in the professionals

During the second lockdown, we had a tight turnaround to design a logo and a website, learn a booking system and do up the premises. Just a few things! When I say we … referring to the website, I really mean Verity Evans of Think Doodle. She is seriously good and also a small local business owner. The compliments we've had about the site are all down to her, and I couldn't be more grateful. The content was really important to us, as we not only wanted to show our services but also tell people our values. I know it could sound fluffy to some, but

actually we really do hold steadfast to our values of putting customers at the forefront of everything we do.

So the big plan started to unfold setting up a photo shoot for the website, a Facebook and Instagram page, and getting a launch date in the diary. Penny Plimmer, a local photographer was absolutely fantastic, capturing exactly what we wanted. But I hadn't used Facebook for 15 years and was locked out of it, and I didn't know the first thing about social media. So, with much help from fellow business owner Naomi Paice of Solent Balance and my 14-year-old son Henry, I managed to set it all up. Although I totally got some bits wrong – like in July people started wishing me a happy wedding anniversary – our anniversary is in December, so I definitely have more learning to do. But I found out how to connect with local business groups and have really enjoyed listening and learning about what other people are doing out there. I also love it when someone likes one of our posts or makes a comment. I have on my list to go on a social media training to learn more about how to use it to get our clinic out there.

The products we stock are by Image Skin Care. Leigh Wilson, the most beautifully groomed lady in the world (don't take my word for it, you can see her on her Instagram), has really guided us in the type of products we want for our customers and the treatments that we offer them. She joined us for our launch and did some amazing facials from the 02 and Signature ranges whilst our guests watched, sipping posh bubbles and of course eating cake! We took bookings at our launch and have been taking them ever since – it's all happened so quickly!

Continuing professional development

In recent years I've found business coaching to be a real saviour, especially when it comes to deciding what to do next.

My mind can become cluttered with ideas and wants to take me in 100 different directions at 100 miles an hour, so taking some time out to reflect with someone who is just there to help me do this is ideal. I also find that having someone neutral to talk to helps so I'm less of a burden on my friends, who are probably fed up with listening to the next saga or occurrence in my small business world. My coach Ali Hughes of Hughes Lewis Consulting has a beautiful office based in Stanstead Park. I've spent many an hour walking and chatting with her about the challenges of juggling two different businesses.

I also find that books help me develop as a businessowner. One I've read recently that I related to is *Help Me!* by Marianne Power. This lady doesn't know which self-help theories will help her the best, so she tries the lot of them. There is a public speaking section where she's really scared of it, but she pushes herself to do it. I often feel the same in many things, and in fact when I read this chapter I'm writing out loud, I know I'm going to feel out of my comfort zone. The last time I had to do anything like this I was at school, and even then, I remember my face heating up when my name was called to stand up and read aloud.

With each new day and each new challenge our busy minds may need to reach out to different types of help, whether it's a chat with your sister, a drink with your neighbour, a walk with your business coach or a quiet read of a self-help book. I have realised taking time to reflect has been an important part of the process of deciding what direction to take my business in. I have learnt that trusting in relationships with the people you work with is the key.

Finally, I would love to tell some of the people who judge what we do in the aesthetics industry how much relief, comfort, and joy it brings to the people we work with. Coming from clinical backgrounds, Kellie and I feel the same. It's a true pleasure to give a safe and comforting service to people who really

need it. I love that this is my path, and it is the right one for me right now.

BIO:

Jo Mifsud is a director and partner at Pallant Aesthetics Clinic and sole owner and Director of Appletree Support ltd. She aspires to create and grow businesses that care for and empower people to lead the lives they choose. She lives with her husband, two children, and Tiger Lily the Bengal cat. She's been known to attempt to stay on a paddle board and loves baking cakes – but more so eating them.

www.pallantaesthetics.co.uk

16

I NEVER WANTED TO BE SELF-EMPLOYED

Fiona Sanderson

I never wanted to be self-employed. It just wasn't something I had ever considered. I was comfortable with being an employee and leaving the big decisions to someone else.

But, in a single month in 2012, I was made redundant from a charity where I was employed as their Financial Controller when they restructured, and my other employer went into receivership. Suddenly, I had no income, not even the benefits upon which I had been so reliant for the previous decade (more about that in a mo).

Fortunately for me, the second employer, a Bookkeeper, offered to give me the clients I had been working with for her, and suddenly I was self-employed with a ready-made partial client base.

Oh my word!

I never wanted to be self-employed!

This really wasn't me. I mean, I was ok with the accounting side of things, but I'd not planned this, I didn't know what insurance I needed or what providers were right for a Book-

keeping Practice, what about regulation and Anti-Money Laundering, finding clients, OMG am I going to have to go networking and stand up in front of a bunch of people and talk? I can't do it. I can't. I can't breathe!

Of course, I did start breathing, I didn't have the breakdown I felt I was close to, and I did manage to get myself regulated, insured and all that other malarkey. Before I knew it, I had found an additional two clients to keep me busy enough to pay my bills and keep my cats in food.

Wow! I am actually self-employed, who would have thought it?

My engagement with one of those clients was a strange one. The Ops Director of an arts charity was looking to employ a temporary Finance Manager, I talked her into engaging me rather than employing someone. Ironically, when she offered me the position, I turned it down because I was concerned that I was committing to too many hours and may crash. We had a coffee and over two hours talking about all sorts, Tracey talked me round and I agreed to work with her.

Little did I know then just what a change that decision would make to my life.

OK, so I've made more than one obtuse reference implying something to do with my health, so let's backtrack here, way back to 2001. In fact, let's go even further!

I graduated in 1995 with a BA(Hons) in Financial Services and went straight into an accountancy practice as a trainee to study for my chartered accountancy qualification. Six months later a combination of things made me change jobs. I jumped ship and moved into industry working as an accountant in business, it was here I completed my Chartered Management Accountancy qualification.

In 2000 I got a fantastic position locally with an international company. A dream job at the time – reporting,

analysing and explaining numbers, forecasting and projecting costs. I quickly got offered a temporary promotion.

I was pumped. Scared about the challenge but pumped that they thought that much of me so quickly. I was inexperienced and was promised support, but it wasn't that straightforward.

Just before I took the temporary promotion, I went on holiday but caught a virus on the plane home. I took no time off to recover from it as I needed to get stuck into my new responsibilities. I soldiered on. I struggled. I was working seven day weeks, but no matter how hard I paddled, I just could not keep up and the other managers were too busy to guide or advise.

I was stressed, I was exhausted, and I was feeling like I was a failure. I got signed off work for two weeks to recover. It worked. I felt so much better when I returned. However, that lasted only a few days before all pain and fatigue symptoms were back. And the whole failure (in my new role) thing was bothering me big time.

I believed that it was the job and the lack of support that was making me ill, so I resigned. The FD didn't bat an eyelid saying, 'it's probably for the best'.

Now I really felt like poop.

I had no job, I was feeling ill, I was berating myself for not doing a better job, and I didn't believe I would get a positive reference.

It didn't cross my mind at that point to go self-employed, I don't think I had the life/work experience at that point, so I got another job.

I lasted seven weeks before I was signed off by the Doctor again and given a diagnosis. I was told I had ME (Myalgic Encephalomyelitis) or what some know as CFS or even the derogatory term Yuppie Flu.

I was drained, I couldn't even follow the plot of a daytime soap. Sleep was non-restorative; I was riddled with pain and had many other symptoms. After seven weeks on sick leave, I

took the 90 mile round trip to see my manager who throughout had been really understanding and completely fair. We talked and I suggested that it might be best if I resigned. He agreed.

Around this same time, I saw a specialist and was diagnosed with Fibromyalgia as well as ME. Great! But at least I had labels I could look up.

And so began 8 years of being unable to work.

I spent a couple of months virtually bed-bound, at least three years house-bound and the remainder I was capable of doing a little if I paced myself.

Waiting for Benefits – oh the shame I was made to feel – took forever, so I was living off my credit cards. Waiting for my Income Protection Insurance claim to be processed took even longer, and more debt was racked up.

Between us, my then partner and I, filled my credit cards to the point I was taking money off one of them to pay the other, I made arrangements with the credit card companies, I bought supermarket brands where possible, and shopped around every year for insurance and utilities. Everywhere I could, I scrimped. But it was still so difficult to balance the budget, and me, an accountant.

In November 2007 I finally took the truly difficult decision to petition my own bankruptcy. Bless him, the judge I went before granted it immediately and went on to say that there was no way I could concentrate on my health when trying to manage money problems. Now, he said, I could go away and work on getting better.

I'd split from my partner so was now alone, penniless and painful. I so needed to feel I was worth something.

This is when I then contacted the Bookkeeper who took me on for 8 hours a week. After a year, suddenly, instead of 8 hours a week, I had to do 24 hours to replace the money lost by working. Eek!

I said earlier that meeting Tracey changed my life. She sure

COMPILED BY TRUDY SIMMONS

did. Not only was I now managing multiple clients as well as my health, but I was also falling in love. This was new. I'd never fancied a woman before.

Tracey and I worked as client and freelancer for about 6 months before starting a discussion about the challenges faced by charities due to a swathe of funding cuts. Typically, the back-office staff would get cut first, admin, marketing then finance, but finance would have taken on the admin tasks and then had their hours cut too.

We wanted to create a hub of back-office services run by charity professionals into which charities could dip as required without the expense of employees or long term, multi-hour contracts. So, we started our business partnership and a few months later incorporated.

Oh, we got married too.

We never did create the hub we'd excitedly discussed because too quickly we became busy offering accounts and advisory services to clients. We have however, over time, built a strong network of charity professionals, including other accountants, and for any area of a business with which a client needs some support, we generally do know someone we can wholeheartedly recommend.

Our team, after 8 years, is still small. We are only four strong and that is deliberate. We believe clients get more from their accountant or business advisor when there is regular contact from the same person. We want to know our clients; they aren't just a number or a fee. When we know them well, we can help them best. It is also significant to mention that making millions was never our goal, having sufficient money to enjoy a reasonable lifestyle was all that was needed. More important was making a difference, giving back, empowering others and helping people to help others.

Almost all our clients now fit into our quite specific three niches: CICs (Community Interest Companies), Charities and

Creatives and prior to Covid, every year had been profitable for us. We had our 'helping people' hats firmly on last year and spent a lot of time supporting clients and non-clients with advice on how to get through the pandemic. Even now in September 2021 we have not charged a penny for any Covid related support or Furlough claims. It's all just a matter of values and company ethos, and we know exactly what ours are.

Don't get me wrong, my health conditions haven't disappeared, I still struggle daily with them, in fact, more so as it happens. I spend at least 3 days a week in bed, in pain, trying to sleep or sleeping, too exhausted to work, cook, converse, watch tv, do anything. Noise and light hurt, I can't regulate my body temperature well, and that is just exacerbated with the start of peri menopausal symptoms... Lucky me!

I work when I can, it might be through the night when I have insomnia, early morning because that is when I'm most productive, or at the weekend because I've been too fatigued during the week to complete all that I should have done. That's the beauty of working for yourself. You call the shots with the hours and days, or at least, you should do.

I predominantly work from home, I don't have much in the way of outside hobbies or other social life, so Covid didn't affect me too much. It is nice now though being able to work in our office and see the team and other people in the building.... A change of walls and air really can be beneficial.

Despite living with chronic illness since my mid 20s which necessitated taking 8 years out of work and a subsequent complete change to my chosen career path, I (generally) continue with a smile on my face, a positive attitude and the support of our small team, to help our clients make sense of their accounts and to build stronger, more successful and sustainable businesses. This is how we help people.

I love being self-employed.

BIO:

Fiona is the co-founder of Miss S Business Support Ltd (Miss S Accounting for Purpose CIC as it will become shortly), a thriving accountancy practice in Hampshire, England, offering business advisory and accounting services to third sector and creative organisations.

She is a chartered management accountant and certified bookkeeper who is driven to help other people. Alongside her work with numbers and around her continuing health conditions she enjoys breeding pedigree Ragdoll cats, spending time in the garden (more often supervising than working) and supporting her wife's hobby as a stone sculptor and all-round creative person.

www.misss.co.uk

ADAPTING TO THRIVE

Pat Maguire

R ecently divorced with three young children, living in temporary accommodation, and working in a job that did not pay enough money. I was a crèche assistant, the job became available a few weeks after the house move and was near my children's primary school, so it was very convenient. The job also offered free school holiday activities, free gym access, swimming and exercise classes, so it was ideal in many ways. I knew things had to change and despite the freebies we needed more money coming in to pay the bills.

I managed to get some part time evening work at weekends working in a hospital kitchen, it paid well and topped up my income nicely, and I met some very interesting people there. It was a stepping stone to where I wanted to be and helped me make some good connections. I now had two jobs.

New skills for a new life

I enjoyed my jobs, but knew I wanted something else, some-

thing more, for the long term. So, I researched various holistic therapy courses and decided the Aromatherapy Diploma course would be really interesting and a step in the right direction but first I had to gain an Anatomy, Physiology and Massage diploma. I enrolled in June but had to wait until September for the course to start. I was so nervous the first day I couldn't eat breakfast, but I loved it from day one.

I didn't have a car at that time, so I had to get a train and walk twenty minutes to the college from the station and back again for each evening class. The winter was so cold and I remember how bleak it was standing on the dark platform every week waiting for 20/30 minutes for the train to come. When I got home, I would thank my mum for helping out with the kids and fall into bed tired but happy. The second year the course ran in the mornings, which was much better. Nothing was going to stop me now.

Two years later, both courses passed, I worked very hard building a clientele in my hometown, the historical town of Winchester in Hampshire UK. I rented a room in a chiropractic clinic part time alongside my main job (support worker for adults with learning difficulties), which enabled me to grow my business with the security of paid employment. I loved working with people holistically; I was passionate about natural health and wellbeing and made friends with many like-minded people, and I got remarried.

Four years later I qualified in sports and remedial massage which was amazing; the course covered an in depth look at the muscular system, revised anatomy and physiology, injuries, prevention and treatment to muscles and joints including reha-bilitation and postural issues. After the course, I felt more confi-dent as a therapist – that I had a better understanding of the body and how to treat certain issues more swiftly.

My juggling act

Juggling family and work was not easy; I worked long hours, some days split into both ends of the day, weekends, and I often attended local running events offering pre- and post-event massage.

I attended regular CPD courses, including advanced sport massage techniques, aromatherapy, and the benefits of new essential oils. I gained a diploma in hot stone massage and started to use them as a great way to help warm muscles prior to deep tissue massage.

I worked in physiotherapy clinics in Winchester and Eastleigh for years, which was a fantastic opportunity. Working alongside a professional team of physiotherapists gave me new experiences, knowledge, and the social interaction that I missed previously.

I worked a day or two at home treating clients who couldn't attend times offered at the physio clinics – these would always be clients I'd been treating outside of the clinics; I never breached contracts: I didn't need to. I am proud to be honest and trustworthy and expect the same in others I work with.

Times of change

Time moved on, my children were older and more independent, and life became easier. I worked 70% self-employed and 30% employed, and I was ready to become fully self-employed. I handed in my notice with my employer, and the following week my second husband and I decided to separate, my second marriage lasted six years.

The following year, my mum died of Oesophageal cancer within months of diagnosis! This was completely devastating and traumatic for my family and me, but especially so for my poor dad.

It was really tough running my own business at this time of

my life. I wanted to be with my mum more than I was able to, and I felt out of control with what was going on around me. My mum was slipping away and there was nothing I could do about it; the marriage breakdown misery paled into insignificance and the pain in my heart was immense.

Four months after my mum died I just wanted a break from the pressure of being in demand all the time. One of my clients invited me to join her group on a trip to Turkey, I managed to join the holiday booking, and off I went four weeks later. The holiday was amazing; it was a wonderful time to be calm, reflect, and heal. I returned from Turkey with new energy, new friends, and the realisation I didn't like working in fast-paced clinics with appointments booked back to back anymore. I had got lost in the hectic way of working: I didn't want my clients to be rushed out the door as soon as their treatment had finished; they weren't just a body part! So I left the clinic.

I was offered a room to work from in a natural health practice which had private GPs and offered homeopathy, reflexology, hypnotherapy, osteopathy, chiropractic, and acupuncture treatments. I accepted the offer. The practice, for me, was the ideal place to work from. I remain there today, six years on and very happy. While working as a therapist I've developed an interest in helping people manage pain from postural issues, sports injuries and rehabilitation, painful swollen arthritic joints, and general muscular aches and pains.

Finding new ways to support people and the planet

I've spent many years creating different aromatherapy blends with success and thought it would be a good idea to create a natural soothing balm for people to use at home. I didn't personally like the chemical based muscle rubs on the market, the strong aroma and hot or cold sensations on the skin felt unnatural and uncomfortable. I wanted to create a gentle,

completely natural, effective, soothing muscle and joint balm. When I got to work, I produced six balms, including my muscle easing balm. Since then, I've added luxury face oils to my range. All of my products are approved by a reputable biochemist, and since I got my branding done (more on that below), I've really added a new string to my bow.

I have become increasingly aware of high pollution levels, destruction of rainforests and natural habitats. It's important to me that for my products, I use recyclable glass bottles and jars and eco-friendly packaging. None of the ingredients I use are tested on animals, and I continue to research and source the best ingredients for my products to help prevent further damage to our planet. For example, I use organic beeswax in my balm which is from a small ethical beekeeper. Beeswax is one of the top sustainable waxes, though I know it's an unpopular choice for many, especially for vegans. I recently found a fabulous sustainable alternative – obtaining this alternate wax it is a way of recycling too. I am in the process of producing a new recipe for my balms using this vegan-friendly alternative and hope they will be ready really soon.

In addition to updating my ingredients, I've updated my branding. During lockdown I rebranded because I didn't believe the labelling reflected the quality of my product. The new look is amazing and reflects the ethos of my brand.

Finding ways to work that work for me

The pandemic was a very difficult time to launch a new brand into the world. Suddenly everyone rushed to promote their businesses online, which I found overwhelming.

I felt like giving up, I wondered who would care if I just stopped? So I took a few days to reflect and realised I felt everything was too difficult. I didn't want to be online all the time; I just wanted to meet people in person and let them sample my

products. I hated spending hours stuck not knowing what to post.

Adapting to the situation meant pulling myself out of my comfort zone and coming off social media for a while – I dropped off the radar. Following advice from a friend, I signed up for an online course in Passionate Marketing. The course provided me with the tools I needed to gain an online presence and with more confidence. Now, I sell my products to clients, online via my website and other online sites, and at local online Christmas markets.

I've also found online support by joining local networking groups, including the Hampshire Women's Business Group – founder Trudy Simmons is amazing in her passion for supporting women in business, and I find her energy in supporting others truly inspiring.

When I first started my business, I was passionate about human health and wellbeing. That passion is now stronger than ever, like a flame that can't be extinguished and the light glows brighter with each success and fall.

As I reflect on my business journey, I can see that my success is owing to my willingness to continually evolve as a person, adapt and pull myself up and out of what life throws at me, good or bad. I have met so many wonderful inspiring people on my journey. I even got married to my third husband last year and moved house.

Life is to be embraced. I have never had any regrets starting my own business even through the struggles along the way. It was my passion.

BIO:

Pat Maguire is a sports and remedial massage therapist and aromatherapist in Winchester and surrounding areas.

She makes small batches of natural body balms and oils

using her own recipes and eco-friendly packaging. She uses sustainable ingredients to help prevent further damage to our environment. She is passionate about sourcing safe, natural ingredients because she believes reducing the use of chemicals in products we use on a daily basis can have a positive effect on our health and environment.

www.patmaguire.co.uk

18
I DID IT MY WAY!

Emma Owen

I was 15 years old enjoying my summer holidays when I was asked to help out at a hotel in Southampton as a chambermaid. I said yes even though I only ever occasionally changed my own bed and thrown the vacuum around my room. The opportunity was one I'd never thought about before but I thought why not it means I get to earn some cash.

During the summer, I worked 5 days a week and I learned to do hospital corners on the sheets, quick ways to change a duvet cover, clean bathrooms, dust, fold towels, vacuum and take criticism and wow there was a lot of that. It was tough and I remember feeling like I was a bit of a pants chambermaid. That was my summer of "96" which in turn led me to work every Sunday as they offered me weekend work and more importantly into the world of working. I worked in hospitality for the next 4 years and it was fun. I worked long hours, starting at £2.50 per hour eventually going up to £3.75 an hour and I earned great tips when I worked in the restaurant or behind the bar especially at Christmas. Now I knew that working in hospi-

tality wasn't going to get me very far, not like people who worked in an office. I'd seen those sorts of people, office workers! They would come into the pub in their suits grabbing their lunch and a pint, I thought wouldn't it be nice working 9-5 not smelling of stale beer, cigarette smoke and not being on your feet all shift. I was led to believe that to make money you had to work for a big company, think Fortune 500 big, that you had to start at the bottom and work your way up, or go to University, (I hated school I never understood the point and it was boring). So I decided that starting at the bottom in an admin role was best for me.

However it didn't matter what the size of the company was I never felt like I fitted in, nor was I getting where I wanted to. I felt like a number rather than a person and I wanted to make money and make it NOW. I saw the sales people in the companies I worked for earn not just a salary but commission, Cha Ching!!!! They wore smart suits, smelt great, always smiled and drove nice cars. Yes you guessed it, I wanted to work in sales. I worked hard, WOW did I work hard. I worked long hours for 10 years and 9 of those I was a single mum who never saw her daughter because, well, I was working, but for what? I never really had an end goal?

After a while I got annoyed with the targets, the constant wanting more from you even if you didn't have any more to give. The pressure was unreal and I felt like I was in a bit of an emotional rollercoaster. I got offered a self-employed role which brought all my knowledge together, admin, sales and networking. It was for a new company that had come to the UK and they wanted someone with industry knowledge in logistics and I had that. I really enjoyed helping the business set up in the UK and I got to work from home. After about a year I decided that travelling around the UK having to be back in time for school runs really wasn't for me and I handed the role over to another consultant who could give the company more. After

that role I never went into employed work again, I'd conquered my fear of being self-employed.

Then at the grand old age of 37 my world came crashing down when my daughter's health became unstable which made me unreliable, so I gave up working. I went from working 40 plus hours a week to 0. My days consisted of doctors appointments and collecting my daughter at random times of the day, because she wasn't coping and it had to be now, no waiting around. I was also pregnant again, my partner moved down from London to Winchester and let's throw in a house move as well. My life has just got a whole lot more busier than I'd ever imagined. Thankfully I'd met my now husband who was able to support us whilst we dealt with the best way to support my daughter. But then what? I'd gone from working since I was 15 earning money, working my way up the company ladder to literally doing nothing. I actually lost who I was, my purpose, other than a mother and a partner, who could keep a home clean, cook and make things, ohhh I loved to make things.

So now what? I couldn't carry on this way, my daughter was on the right path and stable, my middle daughter was ready for nursery and I had the most content baby. I knew I was very good at throwing myself in at the deep end, and as my dad announced at my wedding last year "I never have to worry about Emma, she will always find a way of getting where she needs to be". It's true, I mainly do this by asking questions and talking to lots of people. I've always asked a lot of questions even as a kid and if I wasn't happy with the answer I'd ask someone else. Or rather I learned to communicate. I did at one point in my career get paid to talk as an introducer or professional networker whatever the title is. I'd learned to listen to my clients needs and ask the right questions and I was good at just getting on with it and getting the job done. People used to pay me for what adults used to get annoyed with when I was a kid. Ha!

Now, no matter how much I knew I needed to be there for my family. In the back of my head I knew I had to make money. So I tried every Multi-Level-Marketing business you can think of, some successful, some, well, at least the kit was nice. I tried, but media sales is like another language to me, I needed to be face to face or at least pick up the telephone, but I just couldn't make the time to do it, I just couldn't find my space and yes before you think it, I was good at sales face to face, Facebook or Instagram errrr just no, it didn't work for me. Don't get me wrong I did make pocket money but nothing too substantial and I definitely could not contribute towards the bills.. I've also never been comfortable with other people paying my way, the government, my family or my husband. So what was I going to do?

I really didn't know what I wanted to do, other than to earn money. Yes I could go into retail. There are lots of those jobs around, but it's not really me. Could I go back into an office? I could but I hated being stuck at my desk. I felt like a caged animal. Then one day I got the opportunity to do an end of tenancy clean. There were two of us to do a top-to-toe clean on a nice 4 bedroom home in Winchester and I actually really enjoyed it and we were done within 4 hours. Then it hit me, I got paid to do something I could see progress with and didn't take days or months to make progress, I had a sense of pride and I got that warm fuzzy feeling. From there Mrs O's Cleaning Service was born. I've used every skill I learned in 25 years. I used my admin skills to set up excel spreadsheets to store client information and track wages. I used my sales expertise and social media skills to open doors, talk not just to clients, but to other cleaners looking for work, I used my past experience to treat others how I liked to be treated and how can we forget that phone call when I was 15 asking me to help out cleaning rooms and making beds.

12 weeks later we have over 35 regular clients, a team of 6

covering Winchester and one covering Southampton. We've done one off cleans, end of tenancy cleans and we are even known to iron! We've had nothing but great reviews and our clients are just fabulous. We work together and are firm believers in "team work, makes the dream work".

Reflecting on my 25 years of working, did I ever think I'd have my own company? Yes. Did I ever think I'd have my own cleaning business? No. Did my CV shock many people? Yes totally, but I needed to learn, develop and grow and do it in a way that made me happy. I can say that every job, every industry I worked in there has been one person who has made an impact on my journey, I took away with me something from each placement and it has made me what I am today and how I run my business.

BIO:

Emma Owen is the proud owner of a Mrs O's Cleaning services, which specialises in supporting families who just don't know where to start on their house from one off cleans, regular weekly cleans and end of tenancy cleans. Helping people bring that sparkle back into their homes and taking off the pressure, enabling you to live your life without worrying about the last time you dusted the skirting boards, mopped the floor or banished those spiders. I've also been supporting people who want to work around their children and lives to bring in money to support their families.

www.facebook.com/mrsoscleaningservices

PASTURES NEW

Meryl McArthur

From an early age I was interested in natural remedies and finding alternative ways to cure ailments. I loved trying them out on myself, my family and friends. Then in my late 20s my parents died within 5 weeks of each other and as a result of this I had sleep issues and struggled with grief.

It was then that I began to research more into all sorts of complementary therapies to try and help myself heal and enjoy life again. I used aromatherapy oils, herbs and homeopathy to help me move forward. I continued this path throughout my pregnancies and in caring for my children.

I then started my first Reiki course and could not believe the positive impact it had on my family, friends and even the cat! I had always been tuned into people and assumed that was normal. However, after I started healing work with my hands, I discovered that I could tune in even more effectively, particularly picking up on the emotional issues of the person I was working on. They would often say they could feel white light

COMPILED BY TRUDY SIMMONS

when I worked on them, but this was something that I didn't fully understand at the time.

Life was busy, as I had a young family and a teaching career, so my healing work plateaued for a while.

Then in my early 40s I was diagnosed with colon cancer.

I was naturally stunned as I had very few symptoms and those I did have, I put down to being busy with my young children, my teaching job and preparing a house to go on the market. Both my parents had died of colon cancer, so it was of even more concern to me and the medical staff that I had developed it, and at an even younger age than my parents.

However, as is often the case with major trauma in life, it became a turning point for me. The following few weeks involved a lot of waiting and worrying during time in hospital. The night before I had my scan to see if I had cancer (although deep down I knew I did), and whether it had spread or was contained in my colon, I was lying in the hospital ward wide awake. It was then I was visited by someone, who I believe was my spirit guide. He told me the cancer was contained in my bowel and I could recover with medical help and by changing patterns in my life that were not good for me. He also showed me that I would go on to use my experience to help others and create a healing business. The strength his visit gave me, along with the determination to be there to bring up my children, carried me through major surgery and 6 months of chemotherapy.

It was during this time when I was often trapped at home that I began to learn and research crystals, chakra clearing, interpreting auras, meditation, herbalism, astrology and working with the lunar cycle. Naturally during this time, I felt very much in the hands of doctors, surgeons and oncologists, all of whom I am very grateful to. However, by trying to do everything I possibly could do to help myself heal emotionally, I was able to take back some control in what felt like a very out of

control stage in my life. After I finished my chemotherapy, I went for some Kinesiology healing. It was during these sessions that I was introduced to Shamanic healing. I discovered that I was very drawn to this way of life and working with nature. It was then I decided to take the next step and use my experience and knowledge to help others.

To begin with I worked only on family and friends as this felt safe, but then through word-of-mouth people began to approach me and ask for appointments. This helped to boost my confidence and self-belief, which wobbled at times, especially as it wasn't a conventional business! I then took the plunge and got some business cards made as things were flowing, people were rebooking and by now I had several regular clients. I turned the spare bedroom into a healing room and created a space where I could treat clients and retreat to do my research in peace. Occasionally, I would go to the client's house if they were not able, or too poorly to travel. Whenever I self-doubted, the universe was very good at giving me a nudge to remind me that I was on the right path. One of my favourites was when I had my aura photographed and I saw the photographer's face when he looked at his screen. As my aura was white, he immediately asked if I was practising healing, and if I wasn't - I should be. It was further confirmation for me that what I was doing was right.

Juggling being a single parent, a part time teaching job and running a healing business was hard and it was often my healing work that I put on pause. However, as more and more people approached me, I decided to take the next step and reduce my teaching hours further. I was fortunate to have lovely support from the school where I worked. I found it so rewarding helping clients to find their right path or making big or small changes in their lives. The feedback from my clients was wonderful, with many of them going on to make significant life changes; a new job, a change of career, end a relationship,

start a relationship, or move location. At other times I would help them through grief, stress, anxiety, or to change sleeping patterns. I have also had the pleasure of helping clients through their pregnancies and then sleeping or teething issues once their babies have arrived. One of my favourite aspects is picking up on the energy and personalities of the babies before they are born whilst working on their mum. This I find so special.

During the first couple of years, I felt the need to complete several courses to verify what I was doing, as this is still an area of society where there is a lot of skepticism. I became a Reiki Master and Crystal therapist, both of which I enjoyed. However, the more clients I worked with the more I realised that I didn't need to put a specific label on what I was doing. I found with each client it was better to go with the flow of what they needed and in turn trusted myself more. I would pass on messages from spirits, even ones that sounded a bit crazy to me, and each time I did, I discovered they made sense to the client. This was a huge leap for me, so now I trust what I am told and pass it on. I also discovered, that sometimes to help heal a client, we need to go back to a past life to release an old energy or pattern that they have brought into this life. At times I am also given the privilege of seeing into the client's future, which I can often use to help them move forward.

No two sessions are ever the same and by accepting this, my confidence and self-belief grew. At the start and finish of my sessions, I always check the energy of each of the 7 chakras and often place crystals on the chakras that need the boost of energy that the crystal provides. More and more my clients expressed interest in this, so I then decided to start selling crystals and crystal bracelets to them to be incorporated into their everyday lives. Originally, I would research which crystal or crystals they needed, but over time and with more self-belief I have discovered that I usually know instinctively which crystals they need. I have become slightly better with my time boundaries, but often

my sessions still over run! At times I have had to put my business on pause, as family life has taken over. I've always put my children first, which is something I don't regret at all. However, now that they are older and more independent, I have the time needed and energy to invest in my business.

I love my work and still always have a lovely feeling after each client. I do take a few notes, but usually always remember when I see them next what we did in the last session. When the first lockdown happened, I initially assumed my work would grind to a halt. However, within a couple of weeks several of my clients asked if we could do online or distance healing. I decided to try it under the condition that if it didn't work there would be no charge. We soon discovered it did work and I incorporated different card readings into our sessions. My sale of crystals also increased during this time, as more and more of my clients were taking the time to look after themselves and focus on trying to prevent things like stress and anxiety building up in their lives.

Until now, I have been fortunate that word of mouth has worked so well. My next step is to start advertising properly and develop a website to move my business forward even more. I am excited about this, but as it is not my strong point, I am also slightly daunted, and this has probably been a bit of a barrier for me. I have recently started running short courses, which despite my established career in secondary education, was another big step. The skills I have acquired in my teaching career continually help me to be organised and my desire to share what I know and what I find exciting about the world is relevant in both my lines of work.

I feel that in creating my own business I have had to let go of what are seen as life's 'sensible' things like a good pension, a contract and fixed monthly wage. However, I love what I do and feel very excited about the future. The fulfillment of helping people see things a little clearer, make changes which enhance

their lives, or have the confidence to do something completely different is so rewarding. I feel privileged that they let me into their lives and often share things with me that are hard to share. But once they do, I can help heal and start the process of bringing new energy into their lives. What is continually beautiful to see is that they always leave a little 'lighter' and go out with more spark into the world again.

BIO:
Meryl is a healer in Winchester, Hampshire. She tailor makes her sessions based round what the client needs. She incorporates crystal therapy, Reiki, chakra clearing, past life regression and Shamanic healing in her treatments. Meryl also sells crystals, once again prescribed specifically for the individual client. In the introductory appointment through discussion and working on the client Meryl picks up on what the energy of the client is like, and any blocks that need to be cleared. Follow up sessions continue this work and the more she works with the client, the deeper the healing can go.

www.facebook.com/CrystalCaveWinchester

THE ACCIDENTAL ENTREPRENEUR

Julia Phillips

I had no intention of ever setting up my own business. So how did I find myself on 1 November 2011 launching my first event agency? On the one hand there was some logic - my daughter was only six months old, and I had just been made redundant. On the other hand, I was, at the time, the primary earner in our household and the event industry was already crammed with good agencies (someone at the time told me that there were more than 10,000 in the UK alone).

The very beginning, a very good place to start

At the start I worked on the kitchen table. I was very lucky; my old boss was able to give me some project work and so for the first five months it was almost like working part time at my old job. When I finished work every day, I would pack all my bits and pieces away in the cupboard so that I was not always 'at work' and I got to spend some precious time with my new 'small human'. Pretty soon it was clear that these halcyon days

would not last and so I needed to go out and find myself some real clients.

So, I started networking. I tried a wide variety of groups to start with (thankfully most allowed you to attend free of charge for the first visit) and the one that suited me best was a women's only group. It was a great local group, and I am still connected with some ladies from those early days. It was those early meetings that gave me a hint of the external support network that is so useful when you run your own business.

Gradually I won a few more clients and moved from the dining room table into the box room upstairs – my daughter was upgraded to the larger spare room – and I got so busy that I needed help. Pretty soon, we needed to have an office, so we built a shed in the garden and my very tolerant team worked from there (tolerant as there was limited space for everyone, limited heat in the winter and no bathroom facilities without a short walk to the house).

Recruiting was a new area for me, I have always interviewed new staff but never without the support of an HR department and an initial paper sift. I inclined towards people who I thought would 'fit in' with the team and, for the most part, I was right. However, I did hire someone to do some sales work for me who was a lovely person but totally unfit for the role. She came to me very unhappy in her current role and desperate to leave – I was keen to help and so made a role for her that was just not suitable. We both suffered from that decision!

What did I learn?

- Not having a pipeline is terrifying
- Making a poor choice in recruitment is not as damaging as ignoring the problem to avoid confrontation

When two became one

After four years we had some great clients and a fabulous team of 3 people. One of our steady clients was, in its essence, one person who was great at selling but not delivering and so we gradually began to work more and more regularly as a team: him securing the business and me and the team delivering the events.

On the face of it we were busy, we were growing, and we were successful. However, we were busy because we were cheap, and we were growing because I was paying other people and not myself. We were still hitting our monthly mortgage payments but only just and I could not tell anyone as I feared letting everyone down.

So when (on the first bank holiday Monday in May) I was offered the opportunity to merge with the agency we had been delivering for, the weight of the world was lifted. He offered a lump payment, security for my team and critically the move would ensure that I was not doing everything from selling to delivery all the time. Perhaps now I could sleep?

What did I learn?

- If it sounds too good to be true, it probably is (spoiler alert for the next section)
- Isolating yourself does not make problems smaller, in fact it amplifies them

The great divide

What a change in mindset – the sky was our limit. I suddenly had the clarity and the ability to lead and grow a team. I was clear to deliver amazing and creative events and life was good. We moved house, we paid off our debts and everything began to ease. Sure, I was still responsible for a lot from HR to

finance to IT to marketing to operations and even (more regularly every month) sales, but it was so good to be achieving and not fearing failure.

Two years on and on paper we were flying. We had more than doubled the turnover, focused on making the business as profitable as possible, and built a good team around us. However, beneath the surface the cracks were beginning to show between me and my business partner. He literally had the sky in his vision and was constantly reviewing business acquisition opportunities, wanting to pitch for work that was outside of our agency scope and squeeze every penny out of every opportunity. In contrast I was keen to grow through account management and recommendation. Board meetings were increasingly feeling like I was not answering the requirements of the business strategy and, once again, the smell of failure was in the air despite all appearances.

Added to this was the increasingly uncomfortable realisation that my business partner was a difficult man to work with. I spent a good deal of time dealing with unhappy team members, and my diplomatic skills were being put the test daily and then clients started to request that he was not present on events.

In the space of 8 years, I had gone from no pipeline to a business turning over more than £2m per year. I was proud but I was exhausted. And then two events – a (thankfully) false health scare and a global pandemic. The first, which came in July 2019, made me completely reassess where I wanted to be and who I wanted to be working with. The second, in early 2020, took any semblance of control in that decision away from me and we parted ways in June 2020. I was a shell of my old self, and the following few months were a very dark time in my mind.

What did I learn?

- Nothing is more important to me than choice

- I thrived on running a business, learning new skills and being pushed out of my comfort zone

From the ashes rises something glorious

One year on from the end of that chapter, a new event agency was born. One that takes on board the lessons I learned, and I am excited to learn new lessons over the coming years. I was totally unprepared in 2011 and now, 10 years on, I at least have some idea of the landscape ahead.

First lesson – rather larger and faster than I imagined

One of the keys things I have invested in over the years, is taking time to work on the business as well as in the business. Particularly as an operational person, it is too easy to get overwhelmed with operational matters and just allow the business to float. I had not let that happen since 2015 and the new agency was no different.

So, the end of October saw me take two days away to work on my new business. You see as well as a new event agency, I wanted to help other business owners avoid burnout and so I invested a lot of time (and money) into setting up a new business. One that would allow me to explore a different business model and keep me focused on health and wellbeing.

It was a membership group model where I would curate information and help business owners find their own tools that would work for them as individuals, within their industry and against the context of their home life. Everyone said it was a good idea, we had a good amount of interest, we were 24 hours away from running our first group and ... I cancelled it all.

I realised that it is a great idea but that I was not the person to run with that idea. My skills are based in the event world and

in building a successful business not in the world of health and wellbeing. The latter is something I am interested in, and I don't think anyone should underestimate its importance, but it is not a business that I want to run.

What did I learn?

- Having a good idea does not mean that it is a good idea for you
- Being honest and up front with people (I cancelled with less than 24 hours' notice) is scary but in the end those people I want to have in my world appreciate honesty and they understand

And then?

I am not sure I have all the answers, but here is what I do know and how I am going to head into the next ten years of being a business owner.

Delegate the things you are not very good at

I am not an expert in all things and therefore I will delegate the areas where I have the least impact – administration, networking, and marketing planning. I have proven that I can turn my hand to most things, but the results vary so now I will work with a team of people who are experts in those fields.

Do not shy away from the tough conversations

I have never been good at confrontation but my fear of it has cost me dearly in the past. I am fair and will try to work out a solution as best I can but if there is a need to part company, I

will not let it affect my stress levels to the point of ill health. Nothing is worth that.

Find your business tribe

My business tribe are my support network for when things go well – and when they don't. They surround me with their visions, energy, and ambition in a way that my friends and family can't. Finding a tribe who have no agenda in your success or failure is such a powerful tool.

Choose to enjoy what you do

We can choose to be positive, happy, and engaged with our businesses. There will be tough days and there will be times when we question what we are doing and, for some, the business owner road will not be a journey they want to pursue. For me, I am lucky to love the industry I work in, and I choose to work hard and enjoy it as much as I can.

Take care of you

As a business owner people depend on me – my family, my team, and my clients – I don't want to let them down but to give the best of me to the business I must look after myself. For me that involves spending time outside (in any weather), watching the sea, laughing with my husband and daughter, having a massage, gazing into a fire, going on trips away and watching chewing-gum tv. For you that may be something different – every person has their own tool kit.

BIO:

Julia Phillips is the owner and lead Event Director of Potting Shed Events which launched in 2021. After graduating with a law degree, Julia fell into events and has remained there ever since. She set up her first event agency in 2011 and was invited to become a founder member of The Guild of Entrepreneurs in January 2015. Her new agency, Potting Shed Events, is an ethical agency based in Hampshire, UK.

www.pottingshedevents.co.uk

ISLAND LIFE

Lucy Griffiths

It was the day of my annual appraisal at the digital marketing agency I worked at, back in 2010. I had been there for a couple of years and felt confident in my role and was, therefore, looking forward to hearing feedback about how my employer felt I was getting on. I knew my portfolio value was the highest in the business, and I had built great relationships, resulting in my clients staying with me.

'We like what you are doing and can't fault your client work but ... we think you are a bit of an island!'

The words knocked me, and I had no idea how to respond to this at the time. As I drove home that night I knew my time working for someone else had come to an end, and if I was an island I was going to make this a positive (rather than a negative) and be an amazing island, so in the words of Hugh Grant in *About A Boy*: 'I am an island. I am bloody Ibiza'!

Doing SEO before it was cool

My husband (then boyfriend) had been encouraging me for months to start up on my own, and that night we decided I would hand my notice in at work and see if I could do Search Engine Optimisation (SEO) and Pay Per Click (PPC) for local businesses on my own. This was back in 2010 (Apple had just released the iPad and Instagram had only just gone live), when SEO was not cool and trendy but considered a little bit shady and most people offering SEO were web developers who offered it as an add-on with no reporting or accountability. I had, and still have, strong ethics about being transparent and showing clients exactly what they were getting for their money and that SEO wasn't some kind of black magic.

Offering this as a standalone service as a consultant with full reporting was a gamble, but I felt if a larger agency could sell these services to big businesses, there was definitely a gap for me to help smaller businesses.

We decided that I had 3 months to get to the point of earning £1,000 a month; otherwise, I would go and work in the local Sainsbury's part time to supplement my income while trying to get the business off the ground. This would mean four or five clients on a monthly retainer of £200 a month. This was the start of my new self-employed life at the age of 28.

Opportunity for development

As the business, then named Simply Search, grew over the years and I attracted more clients, I needed to take on staff to help with the workload. The idea behind the business name was I wanted to make search engine marketing simple, so Simply Search seemed a good fit. Since this is an emerging industry with no fixed rule book, it is very difficult to find qualified and experienced staff. When I reached the point, after three years, of taking on my first employee, I quickly realised that finding a

fully trained SEO or PPC Account Manager was going to be tough.

It was at this point I realised I had an opportunity to teach and train others about the evolving world of digital marketing, as, let's face it, they weren't going to learn about it from a textbook or in a classroom. Even until this day, nurturing, learning, and training remain at the core of Front Page Advantage, our current name, amongst our staff and even our clients.

Balancing business and life

It has been a challenge over the last eleven years with various life events happening. When it's your own business there is no holiday, especially when I have a strong relationship with many of our 70 clients. I remember the day before I got married, I spent most of the day building a new PPC campaign for my biggest client at the time. Or the day after the birth of my son, Josh, it was month end and the invoicing needed doing, so out came the laptop – not sure what the midwife thought when she popped round to check on us!

There are many things which are very different now. Firstly the business has changed shape in a number of ways. In the beginning it was just me and I did everything; now, we have a team of seven and everyone has their own responsibilities and roles. I am now mainly client focused, developing strategy for campaigns, training the team, and generating new business; whereas areas like finance, HR and legal, which I am not so strong at, I leave with others that are able to do them well. This makes me far happier as an individual, and I don't get bogged down with tasks which don't come naturally to me.

Remote work

In January 2014, my husband was offered a role as Finance Director of Sub-Saharan Africa for a multinational. This would mean moving to Johannesburg in South Africa. It was one opportunity which we couldn't pass on. The start date was basically as soon as we could get our visas. In the meantime, we had to work out what to do with my business.

I had done some work for another small digital marketing company in Reading, and I knew that they had a gap in SEO skills. I approached the marketing director and explained my impending exit from the UK, and we were able to strike a deal where I sold Simply Search in exchange for shares in his business called Front Page Advantage. My new role was commercial director and the team of two had suddenly now jumped to a team of five. By merging the businesses together we were able to keep a physical presence in the UK, and I was able to work remotely.

After four years in South Africa, we decided to return to the UK. Now if you remember from the beginning of this chapter, 'I am an island', which generally means I do things my way and co-leadership probably isn't one of my strong points. Within six months of returning to the UK, I bought my co-director out of the business, and once again I was in sole charge of the business. By this point Front Page Advantage had an office in Basingstoke with a team of six.

Working with my other half

Now this is where I decided to let someone onto my island (he was probably already on the island). They say never work with your other half, well......yes Chris joined the business as a director to look after the finances and manage the accounts. When we returned to the UK, Chris was enjoying a career break

and joined the business in the beginning to just manage the finances. An area I always struggled with.

In his previous multinational roles he was growing and driving businesses forward, so I'm pleased to say that this has worked well for Front Page Advantage. I do what I'm good at, and Chris does the same, with us being able to work together on bigger sales pitches to demonstrate our service and expertise.

The team of seven is now a mix of experienced account managers along with two junior roles, one of these being an apprentice. This means we are able to pass on our experience and knowledge to hopefully grow our team organically. Due to Covid, there is a massive skills shortage in digital as every business has gone online.

What's changed?

The biggest change from the beginning to now is that I used to spend long days by myself managing my clients. Due to having two young children – both under 5, with one of them being diagnosed with Leukaemia in November 2019 – I can't be working all day every day. There are times I need to be away from the business and focus on other issues. With the great team we now have in place, this can happen, and the business still thrives.

We remain specialists in SEO and PPC, exactly the same as the business I built eleven years ago, and many of the packages we offer are still based on a similar style of offering to what I offered in the early days. For example, we operate on 30 days' notice terms instead of long contracts where clients feel tied in. It allows everyone to be open about what is working well and what is not.

At the start of March 2020, when the Covid pandemic first set in, we lost about a third of our business. This was mainly

owing to businesses feeling nervous and them trying to restrict their outgoings. But after three months, nearly all the clients came back. In addition to that, we have seen healthy growth.

The plan going forward is to grow to a team of 10, which will consist of account directors and managers. However, we want to keep a number of junior roles to allow people who want to enter the digital marketing industry to start in a well-paid job from the beginning. This is a growing industry, and we feel an obligation to help it grow ethically and responsibly.

BIO:

Lucy Griffiths has been a Search Engine Optimisation and Pay Per Click specialist since 2003. Lucy founded her first agency, Simply Search Ltd in 2010 which was then merged with Front Page Advantage in 2014. The business is now family owned with husband, Chris Pearson now a co-director. Lucy and Chris juggle running the business with their two young children Tessa and Joshua. Outside of work, Lucy is a keen runner completing over 15 marathons and regularly plays tennis.

www.frontpageadvantage.com

22
DO YOU LOVE WORK OR ME MORE MUMMY?

Lisa Dickson

When my daughter Casey was only eight, she asked me "Do you love work or me more mummy?".
I was mortified.
It stopped me in my tracks.
I was working as a financial controller for a fairly large company. We had new owners, new directors, a new management team and a new but hugely ambitious (read unachievable!) profit target for the year.
I had been working long hours, late into the evenings and weekends. I had promised and then cancelled multiple trips, playdates and time with my family.
I was missing playtime, mealtimes, bedtime stories and putting my kids to bed. I was missing school events, teachers meetings and doctors appointments working towards unrealistic deadlines for projects that were not even aligned with company objectives. But it was my job to build the budgets and it was my responsibility to deliver.
The night my daughter had asked me if I loved her or work

more - I had just told her we would not be going to the park at the weekend because I had to work. She asked the question so innocently and without any malice, her big blue eyes felt like they were burning into my soul waiting for an answer to the question that had shaken me to my core. I felt like I was letting down my family, letting down the people I loved most in the world - I was putting my job first and for what? To help other people make money? I was on a fixed corporate salary so wasn't even getting paid for all the extra hours I was working! But I worked them because I felt I had to.

The mum guilt was real!

I said to her. "I promise that I love you more."

Happy with that answer she went off to play with her older brother Cameron.

She wasn't fussed that she would be missing the park tomorrow, she was used to it.

Maybe Paul would take her to the park, maybe not. Paul was struggling with day to day childcare responsibilities. He is ex-army, the alpha male, hunter-gatherer type. He has done tours in Bosnia, Cyprus and The Gulf. Then when he was 32 - when I was pregnant with Casey - he had meningo-encephalitis which nearly killed him. It left him with chronic fatigue, 24:7 migraines and a whole host of complications due to his acquired brain injury. He survived but was unable to work so took on the role of stay-at-home Dad.

Her words kept repeating in my head.

I promised her I loved her more, but it was time that I proved it and started putting my family first.

Later that night, once the kids were in bed, Paul and I sat down and had a very long conversation. I was stressed, unhappy, feeling burned out. I hated the job I once loved. And missing out on so much family time was hurting them too. Paul was struggling with the kids - they were both at school so all he had to do was drop them off, pick them up and cook dinner but

the constant migraine and fatigue was really debilitating. He was on morphine 3 times a day to manage the pain. I hated the fact that he was driving the kids to school while he was taking such powerful painkillers but 8 years of dealing with this meant that we were pretty much pros and knew what he was capable of and when I had to drop everything and come home and do the school run.

"Why don't you start up your own business?" asked Paul. "No way!" I said. "Who would buy from me?" "How would I get customers?" "What skills do I have that people would want to pay for?" "Seriously?" Asked my husband! "You are an accountant! You are a problem solver! Let's figure it out!"

So we did!

Three months later, I found myself at my first local Chamber of Commerce network meeting. I sit there and watch in horror as everybody stands up and does a two minute elevator pitch. I didn't know that we had to do that! I was sat on one of the tables at the back so I was one of the last to go. I had presented at board meetings and company meetings in front of 100's of people in my corporate career and that had never phased me but this group of small business owners terrified me! I stood up and said "My name is Lisa Dickson, I didn't realise when I came here that I had to do a stand-up pitch so I have nothing prepared! So sorry, I'll be better prepared next time. I am a management accountant, I've just left my corporate job and started up my own accounting business. I have no clients yet and plenty of free time so between now and the next meeting I offer my services free of charge in return for a testimonial. If you have any accounting, bookkeeping or number challenges that you need help with please let me know - I would love to help!"

I wouldn't normally advise anybody to stand up in a room with people and offer your services for free, but I can say I had a queue of people wanting to talk to me!! People who were strug-

gling with their accounts, struggling to talk to their accountant, who didn't even have an accountant yet or were just generally intrigued! I received such a warm welcome, so much helpful advice and enough project offers to last me a year!

I was very specific in what I was offering and agreed 5 projects to work on for the next month. I agreed a start date, an end date and an objective to be achieved in return for a written testimonial for each 'client'.

One month later I was able to stand in front of the same group of entrepreneurs and deliver my pitch - much clearer on what my offering as a cloud accountant was and I was able to share five glowing testimonials. From that meeting I landed my first paying clients and I still have most of those clients to this day, 10 years later!!

Several family meetings later, we decided on the company name 'Caseron Business Management' and incorporated the business. Finding the name took forever, until we settled on Caseron - a combination of Casey and Cameron's name! The in-joke for the next few years would be that I was working for them if they ever complained I was working too many hours! They never did. We later changed to Caseron Cloud Accounting as people thought we were management consultants! Lesson #1 - make sure your name clearly says what you do!

We chose our company brand colours by chopping up a selection of Dulux paint colour cards and spreading all the colours on the breakfast bar! We chose a combination of blue, pink, green, grey – colours that would be bright and fun and very un-accountancy! Then we had the logo professionally designed. We love it and we still use it today! Lesson #2 - Invest in professional design if you want a professional brand! (Although now you can do it just as well with Canva!)

Taking on my first clients and pitching for those first few jobs was quite terrifying, but I knew how important it was to get the pricing right - Lesson #3! I had to make this work and I

had to match my corporate salary since I was the only earner! I reverse-engineered my hourly rate from my target take-home pay. I factored in how many hours in my working week that would not be productive - hours spent on admin, marketing and general business stuff - to work out my chargeable hours. Then worked out what I would need to charge to achieve my desired turnover and after costs, directors' salary and taxes, my dividends!

I created template letters of engagement and proposals for work to be done. I was very careful to note what was in and out of scope of a contract. Or at least I thought I was. Several years into self-employment I took on a client with a start-up business and charged £60 per month for annual accounts and annual tax returns. To me 'annual accounts and annual tax returns' was very clear, but this particular client thought that all accounting services that could ever possibly be offered for a small business would be included in that price. So some months later we had a very long and difficult conversation about additional costs for payroll, bookkeeping and VAT registration. She was very upset and assumed that any accounting costs would be included in her original fee and kept insisting she was paying me for 'all accountancy services'. Fortunately most people recognise if you want additional services you have to pay for them. Same as you do in a restaurant, a garage or a gym. It was a very good lesson (#4) for me in terms of making sure my contract and my invoices are crystal clear! I then created a menu of fixed fee services so clients know exactly what is on offer, what they are paying for and what is in and out of scope.

Lesson #5 - to implement robust credit control procedures, which came after a client went bust owing me a substantial amount of money! It only happened once! In my defence I was trying to help someone out of trouble and ended up doing lots of work for free! Not a smart idea for anyone, least of all an accountant who should have known better!

The early lessons are still great reminders of good business practice and allowed me to build a business that has way surpassed my corporate income. It has allowed me to work from home and spend that precious time with my family.

I still work long hours sometimes but they are my hours, my choice, my time. I can work them around my family. As my kids grew up I never had to ask anyone else for time off. I've never missed a doctor's appointment, a school play, a sports day. Never had to miss another family meal. Paul came off morphine during my first 6 months of running my business - so I had to balance him, the kids, the house and the dog with starting a new business - but we did it and we thrived!

I've helped clients build multiple 6 and 7 figure businesses, buy the houses, holidays and cars of their dreams. Many of my clients have become my friends. Many of my original clients are still with me today. I still love what I do and in September 2021 - we celebrate 10 years in business!

I still work from home with a small team - we have a fully functional office at home which has been commercially rated by our local council. Wouldn't have mattered if it was just me, but we needed commercial permissions to allow my staff to work from my home.

I put my family first and implemented Profit First to make sure we have the money to do what we want, when we want, how we want! Because I built a great team, robust systems and documented procedures - I can leave my business to go on holiday and my team will run the business while I am away!

My daughter has never felt the need to ask if I love her or work more again!

BIO:

Lisa Dickson is founder of Caseron Cloud Accounting and Profit Hackers Membership Club.

Mum, wife and business owner in that order. Her mission is to help her clients build super successful and profitable businesses that give them the freedom to live life on their terms.

www.caseron.co.uk

23

IN THE FRAME

Fi Campos

There was a defining moment for me when I was at primary school, and it involved an old shoe box, some Cadbury's crème egg trays, and a shell or two that I'd found on a bathroom shelf at home. I was painstakingly creating a 1930's bedroom interior inside a shoebox, complete with art deco style lamp (crème egg tray – any excuse) and shell style headboard. It was that exact moment that I remember falling in love with art and design. Fast forward 15 years and there I was, newly qualified with my Textile Design degree, about to start my career as a visual merchandiser and window stylist.

Going all in

I've always hankered after the feeling of success, though I never did nail down what this meant for me at the time. I spent the first decade of my career being employed by various companies, side stepping my way into exciting new styling job prospects. Particularly when I was younger, I tended to just go

for things, and I'd worry about the consequences later. One of these opportunities was presented in the form of upping sticks to Athens and working as a Visual Merchandising Manager out there for a British homeware retailer. It also happened to be the first time I'd ever driven on my own anywhere in the world (I'd passed my driving test just days before moving out there), which also was in Athens at rush hour in a brand-new company car, but that's a story for another time – probably best to just mention that I don't tend to do things by halves. I'd love to say emphatically that I always wanted to be my own boss and work for myself, but the truth is that after having been employed for 9 years, my own business grew from a dismal place...

It was the first moody January day back in the office after Christmas in 2016, and as soon as I walked through the door, I could sense that something was up. I'd been employed in my dream job for around 5 years as a Stylist and Visual Merchandising Manager, and being an all or nothing type, my job was my world. I've always been intuitive, so though I was heartbroken, I wasn't all that surprised to hear the dreaded words: 'I'm sorry Fi, we're having to make you redundant.' And that was it – I left the office 5 minutes later, never to return.

Initially I panicked, and then I wallowed in self-pity for a few weeks; of course I did. But as productivity cures fear, I signed onto the dole and became obsessed with my outgoings, as anyone would be. It was hard having the rug pulled out from under my feet, mainly emotionally but financially too. I vividly remember sitting by myself at home, blank sketchbook in hand, and compiling endless lists of all the companies that I'd love to work with, in between firing off my CV to any recruitment consultant who'd read it – desperately waiting for the mobile to ring, or for a job offer to land in my inbox. Neither of which happened. And then it kind of dawned on me after a while. What if there was a way of working with these dream companies as clients, by not putting all my eggs in one basket again?

Passion, redundancy, and being scared but doing it anyway

Turning my dream companies into dream clients solved the rather huge problem redundancy had left me with: my job didn't exist in 'the real world'. I'd come from a retail Visual Merchandising background where I designed window displays and styled products in stores, and then feeling like I needed more from my career, I'd moved sideways into photography styling. So (in my head) it was a far cry from the 'usual route' into the competitive world of styling and art direction, though it was completely logical as styling uses the same skills but for a different objective. I've also often had qualms about the fact that I studied my passion. 'Study languages, it'll make you more money' were the voices ringing in my head from my school days, but I'd purely (and fiercely) followed my heart and studied design. In many ways I feel lucky to have always been involved in the same line of work, but in others it scares me to think that I've never done anything else, so being made redundant was a pivotal part of my decision to create my own business.

I distinctly remember being convinced that my lack of network would be a challenge. I thought the fact that I'd rarely assisted on shoots meant that I couldn't do it alone – somehow completely disregarding the small fact that I'd art directed and styled all the photography campaigns for a furniture brand for the previous few years. It's funny what happens to your reasoning when your confidence takes a bashing, isn't it?!The truth is, I had a real hang up about this aspect of 'side stepping' my way through my career. I felt like I didn't deserve to have success as a freelance stylist, despite having been in the world of product presentation since leaving uni. But as the years have gone by, and I'm now celebrating my fifth year in business as a freelance photography prop stylist, I've come to realise that this beautiful concoction of commercial understanding and creative flair is in fact my superpower; my USP.

So, I guess you could say that I was most definitely thrown into self-employment. In all honesty, as I've already explained, I didn't have much other choice, as there were very few employed jobs in existence with my skill set.

The right place and time

After quickly realising that my only viable option was self-employment until I could find a new role, I updated my LinkedIn profile. Lo and behold, my first three clients came via this platform: direct messages from an event manager who needed a prop stylist, a lighting company who wanted an art director for their Christmas lighting concepts, and a photographer who realised that they could make more money by outsourcing their prop sourcing. I was in the right place at the right time and had crucially updated my profile just as the platform was shifting from being a land of recruitment consultants to where business owners had started to hang out. Having these opportunities happen right at the beginning of starting my own business hugely built up my confidence, which in turn presented me with things that I felt I could talk about. These jobs enabled me to start telling my story, and allowed me to explain (and more importantly, illustrate with photographic evidence) how I could help brands and businesses sell more by up-levelling their product presentation and styling.

Challenges, lessons, and balance

But it's not all been plain sailing. Far from it. I love a challenge, so as well as becoming self-employed, during these past 5 years I've also had two children. This balance of family and work life has been hard to juggle, and I'll be the first to admit that I rarely get the balance just so.

Whilst I am a multi-tasker by nature, I firmly believe that for me to excel at anything, I need to give it my full attention at that moment in time. So when I am 'Mum', I'm parenting. I'm not trying to have a conference call or write emails whilst spending time with the kids, because I simply can't do it all. I have huge respect for anyone who manages to do both, by the way; I've just realised that for me personally, it makes me feel like I'm not finishing anything, which can be a huge anxiety trigger. Yes, it means that I work most evenings so that I can be with the children in the day, but this is really why I am so grateful to have been made redundant, because if I hadn't lost my job, I'm not entirely sure that I'd have pursued this avenue off my own back, and thus wouldn't have the freedom that I now have. Something that my thirties have taught me is that time is one of our greatest values. One of the huge pros to running your own business is having more freedom. The power to work when you want, with whom you want, and how you want to work. It took me a long time to grasp this concept of not needing to constantly people-please, as my biggest fear is in letting others down. I manage this tendency to try to do everything by serving my customers with the best of my time and attention in scheduled work time blocks. If I try to do it all, I can do none of it well and run the risk of disappointing. So I have learned the art of pacing myself, though I'd be lying if I said that I didn't still find it a struggle at times.

Recently, I've noticed that you get back what you seek and project. In the last few years I've seen a distinct shift in both the work I seek and in the companies who want to work with me. The pandemic shifted things online for me a little, and as someone who relies heavily on a skill that uses my hands and needs to be done in person, I found this difficult. However, during the first lockdown I was also on maternity leave, which gave me a timely distance from photo shoots, and meant that I

was able to create some remote styling services. Whilst I love nothing more than getting out and about and styling photo shoots in person, what the online styling consultancy has provided me with is a different string to my bow, and one which has opened my skillset up to helping smaller start-up businesses who may not have the budget for a stylist on their photo shoot. The variety that has come about from this mix of in-person and remote styling is something that's probably more important to me than any other single aspect of running my own business.

What's next?

So, the future – who knows what's around the corner? I've had my head down in work for most of the year, so whilst I do have a plan, in all honesty even I'm not entirely sure that I know what's next myself. But what I do know is I need to lean into my intuition more and develop the skill of really seeing what has been done, rather than always focusing on what I have yet to achieve!What's absolutely certain is that I'm kind of loving this meandering, rollercoaster ride of self-employment a lot more than I thought I would have done when I first lost my job, and I'm excited to find out what styling adventures are around the corner!

BIO:

Fi Campos is a prop stylist and art director for product photo shoots, living in Hampshire with her husband and two young children, and working predominantly in the South of the UK. With 15 years' experience in product presentation, Fi applies her commercial retail knowledge with styling expertise to design and craft photographic sets that help brands tell their

story, connect with their target audience, and sell a lifestyle through their product. Fi offers a variety of services for brands and photographers, ranging from remote prop sourcing and photography set design, through to on set photography styling and art direction.

www.ficampos.com

NEVER TOO YOUNG

Jade Binsted

The easiest way to describe WHY I started my first business is easy – I wanted to use my degree practically and my mum told me to do what made me happy, but as with anything, life is not that straight forward. You will learn why I started my second business further on.

Throughout my childhood while my mum was working, I would go to work with my grandfather, which would include visiting behind the scenes of sports and media events such as Wimbledon, The BT Tower, and Cannes Film Festival.

While giving me an insight and a love into a very exciting and fast paced industry I learnt the art of conversation and essentially networking. I saw growing up how important building and maintaining relationships is and how, who you know matters far more than what you know.

So fast forward to choosing GCSE's, A-Levels, and my degree subject – it had to be media heavy as I was already so in love with the industry. So, throughout my higher education I ensured Media and production had a heavy involvement

finishing with me starting a Media Studies Degree at The University of Brighton in September 2012… which should have been the most exciting time of my life to date.

In July 2012 I embarked on my first 'no parent' holiday with my best friend and mid-way through us enjoying €7 'fishbowls' filled with goodness-knows what, hangover induced sun burn and more chicken nuggets than you need for an army, I got a phone call that changed my life forever.

It was my mum calling me to tell me that she was going into The Priory for Alcoholism rehabilitation, and she would not be home for at least a month, which meant I would be going home to an empty house and have no contact with my mum.

A quick side note; growing up, my Mum and I were very close – for over half my life, at that point, it was just the two of us and while I knew she was an alcoholic I would never talk to anyone about it and certainly would not label it – which I now know was due to fear and denial. She has always been the very best mum and I have always had everything I needed.

I returned home from my holiday to an empty house, my Stepdad was abroad with work and I had no contact with my mum – which considering we have always spoken to, or seen each other every day, was HARD.

During her time at The Priory, after the period of no contact, I went to visit and for family therapy sessions, which were emotionally draining but to be honest, now I cannot remember much from them except I suddenly had 18 years of grief and poor mental health bubbling to the surface.

So, my last summer before heading to university was not the one I was expecting as I had to very quickly grow up and then head off to University without my mum seeing me off which I know now, had a big impact on my time at University.

However, I had the BEST three years, made great friends, found a partner who I am still with today and got the obligatory graduation photo (and the degree of course).

At the ripe age of 21 I graduated fresh out of University ready to start my long-anticipated career in the media industry. I had spent my time at university building relationships with media companies in London, where I had a particular favourite where I thought "I'd love to work here" which paid off hugely as I was offered a PA (production assistant) role straight out of university WITH THEM, which none of my friends had. However, I was also already working on a self-employed basis for a local small business managing their marketing and video production.

As you may have guessed I had a decision to make – do I go for job stability with a salary and career progression in an industry which I have spent the last seven years studying for or do I try out this self-employed thing and see where it goes. As you can imagine, my head was spinning but my gut knew what to do. After speaking with my mum, she told me to do what would make me happy.

In October 2015 I registered my first company Ribbons Media, offering Video Production and Marketing to small businesses to the client I already had and another client who needed weekly videos for their YouTube channel.

In my mind, I had it made – regular work, time off whenever I wanted and work in the industry that I had trained to work in.

However, as with most entrepreneurial spirits, I knew I was not done (an obvious statement for a 22 year old, I know) and I knew I wanted FAR MORE!

Therefore, I looked into ways to grow my business and spoke with others who were Self-Employed and Business Networking kept arising. Well, even for a fairly confident person, this scared me but I am not one to shy away from a challenge, so I booked a meeting… 60 miles from where I live. The meeting was being held at my favourite place on the Dorset

coastline so my mentality was, if I messed up, I would never see them again anyway.

Imagine it, there was me, driving down to Boscombe on a Tuesday morning, roof down (such a poser) and mentally preparing myself for meeting a room full of strangers and 'pitching' my business to them, I very nearly didn't go in... but I did and it changed my whole business life.

After the meeting (which, yes, I loved), the host, Dawn, asked me if I would be interested in running a meeting for her in Hampshire. I have already said that I am not one to shy away from a challenge so I said YES!

In May 2017 Hampshire Dynamic Women in Business was born where I ran monthly women's networking meetings on behalf of Dynamic Women in Business in Hampshire. I absolutely loved running these meetings for the support and friendships I got from those who attended and running the meetings took Ribbons Media to a whole new level.

In the year I ran Hampshire Dynamic Women in Business I won Business Networker of the Year 2018 with The Venus Awards which was my first real 'proud of myself' moment and it cemented to me that I was on the right tracks, which I have learnt you need occasionally, when running your own business or businesses. I also learnt the art and beauty of collaboration when I collaborated with another local network to run big summer and Christmas events, bringing our networks together, which was epic!

Something else I have learnt since running my own business, nothing is permanent, but there is opportunity in everything. In August 2018 Dawn decided to sell Dynamic Women in Business and I made the decision to step away. Looking back this is the best thing that could have happened to me.

I knew I wanted more from running a network and there was so much more I could do with it. So I spoke with my good friend and fellow business owner Tara Morris, who also does all

my branding, and asked her what she thought of the name: The Ribbons Network. She said she loved it and it fitted in with the brand... so I wasted no time and launched The Ribbons Network to start in September 2018, a friendly, welcoming and supportive network for business men and women.

At the start, I ran 'The Ribbons Network' for three months, welcoming local business owners and asking them for feedback after each meeting. I then implemented these changes to ensure that the group operated with the core values intended, but in a way that was productive and useful for the business owners who would be attending.

I wanted to do this for three months, before then fully launching the membership side of the network and then investigate how to licence the networking group to new areas in the new year.

When January 2019 came around, I fell pregnant with my gorgeous son Louis, so while I had successfully launched the membership for the network, I decided it was best to launch a second meeting location to serve the network I had built up and put the licencing aside for the time being.

Fast forward to March 2020 – I was due to finish my formal maternity leave after spending 6 months parenting lovely Louis and working on the side to then take the business to that next level when COVID hit. Like many business owners, I very quickly 'pivoted' and used my initiative to take the groups straight online. In addition, I understood the importance of a supportive business network at a time when business owners had so much uncertainty, so I added more meetings to enable my members to get even more value. I adapted how other business owners could attend, by offering three different pricing and membership levels, including a free level, so that no business owner, no matter their financial circumstances, was left without support.

I also used this time to dive back into licencing the business,

since the online arena allowed business owners, nationwide, to network easily together. During this time we supported nearly 250 business owners through online meetings, I also achieved my dream of licencing my business to Dorset, Berkshire, Sussex, Cornwall, Kent and most recently, Devon.

Part of The Ribbons Network that I'm most proud of is the charity aspect. At each meeting, we hold a charity raffle and up until recently, I would help raise money for local and small charities that needed support, inviting them along to attend 'The Ribbons Network' as a guest, to gain extra support and exposure from business owners.

However, this year, I decided that I needed to take this to the next level and create a charity that had a backlink to my personal life. I am in the process of registering my own charity, 'The Ribbons Foundation', to support children and young adults who have been impacted by someone else's addiction, as I did not have this support when I needed it. This will include mental health and education support and will be integrated full circle with 'The Ribbons Network' through fundraising and utilising experts within the network, to help those in need while also still supporting small business owners.

Lastly, to tie in with launching in multiple areas of 'The Ribbons Network' and 'The Ribbons Foundation', I organised and ran the UK's very first business networking festival this summer, which I planned in less than eight weeks. This event raised funds and awareness for the upcoming charity, while giving business owners from across the UK a day to come together, learn and build relationships.

This is something that I will run annually and expand as 'The Ribbons Network' grows further across the UK. As well as this, the future for The Ribbons Group involves growing Ribbons Media to have a steady stream of regular video clients, growing The Ribbons Network to have at least one group in each county and to support as many people as we can impacted

by a loved one's addiction through mental health support and education. I hope you have enjoyed my whistle stop story of my business journey. If I can leave you with anything it is to ALWAYS trust your gut even if it feels scary and say yes to the opportunities that excite and scare you... oh and you are never too young to be an entrepreneur.

BIO:

Jade Binsted runs 'Ribbons Media' a Video Production Company, 'The Ribbons Network' a friendly and welcoming national business network and 'The Ribbons Foundation' a charity supporting children and young adults whose lives have been impacted by a loved ones addiction.

www.ribbons-group.com

SIX THINGS I WISH I'D KNOWN
BEFORE I STARTED MY BUSINESS

Claire Anstey

For weeks I've been wondering if I should tell you about the tragic life experiences that "woke me up" or the two business failures that enabled me to "fail forward".

But then it dawned on me. Why don't I just tell you the stuff I wish I'd known 10 years ago.

I have two different businesses, The Operation Goddess Hypnotherapy & Wellness Studio For Women, and The Kambo Clinic. One of which we'll probably sell next year for a nice profit. Not bad for four and a half years of focused work.

Sounds sexy, doesn't it?

So, let's have a reality check!

I'm 42 and single. I've been living with my parents for 18 months, and I have two "jobs" to keep my cashflow going. Both jobs require night shifts. Today, I got home at 6.30am; I've had 4 hours of sleep. This shit has been challenging. Owning a business and fulfilling your dreams isn't a walk in the park. It's taken me ten years and so much failing to get to this point!

It's been so hard. But I'm now in a position where I love it, and life is moving forward brilliantly.

I'm the happiest I've ever been, and finally, I can see the light at the end of the tunnel. The last decade of shit has been more than worth it, but I don't want anyone to go through what I went through.

I don't want you to have to push through 10 years of mistakes and disasters to achieve your business dreams. I had no help, and I took advice from idiots. I didn't believe enough in my ability and got scared. This caused me to chase money rather than be in alignment with my heart and my talents. I've also paid off three credit card debts of 30k and lost my 50k house deposit whilst trying to build a "unicorn" business idea.

I was a bit of a wally in the past!

Though I was broken, I kept going. I healed and finally started to believe in myself, and when that happened, everything changed in my business life.

I've been on the right path for the last 18 months. I'm full of passion and bursting with pride.

Keep reading for the six most important lessons I have learnt.

1: Heal your co-dependency and self-abandonment issues

Co-dependent behaviour is a significant issue in the modern world. It's like a cancer running through all our relationships. Its ripple effect is more potent than you could ever imagine. Healing my co-dependent behaviour and self-abandonment issues have been amongst the greatest gifts I have ever given myself. These issues were at the root of everything that was going wrong, and once they were managed, EVERYTHING changed. I became confident, I became a good leader, and finally, I was a businesswoman.

. . .

Signs of co-dependency include:

- Having difficulty when making decisions that support your needs and integrity
- Struggling to identify your feelings and take supportive action
- Feeling shame when it comes to communicating your true self
- Valuing the approval of others more than yourself
- Lacking trust in yourself and having poor self-esteem
- Having fears of abandonment or an obsessive need for approval
- Having an unhealthy dependence on relationships, even at your own cost
- Having an exaggerated sense of responsibility for the actions of others
- Feeling helpless frequently
- Wanting to be saved by others and/or your business

I had no idea how emotionally destructive and abusive I was to myself while in my co-dependent relationship. There are some fantastic books on the subject, and I was able to heal myself through a combination of reading and taking part in daily breathwork sessions. These sessions enabled me to release the built up trauma that was stuck inside my body.

For anyone in a similar situation, remember that co-dependency is a learned behaviour that can be passed down from one generation to another. It is not your fault you are co-dependent, but it is your responsibility to heal it and change.

2: Never give up your income stream

Your business will always be a side hustle until you can pay yourself. Don't pay yourself until you have your team in place or have had a steady income for at least six months. If, of course, you are a business of one, things may be slightly different, BUT never give up your income stream from your "job" until you have your customer recruitment process in place. If you cut your income stream and then run out of customers, you'll be in serious trouble. You'll also start making business decisions from panic and fear. This won't be good for you or your brand.

I've had one of my businesses for three years and still don't get paid from that one. Our aim with this business is to scale it until we sell. This was the agreement with my business partner from day one, so I knew this would be the case. You, too, will have to make choices and sacrifices.

Cashflow and a financial plan are crucial for business success. It took a dreamer like me years to understand this. My partner and I test everything we do, which gives us freedom. We don't wing it. You shouldn't wing it. Don't think that saying ten affirmations a day will get you customers. My woo woo beliefs alone never helped me meet my business goals. I only saw sales and money come in when I added sensible strategic planning and started taking action. Do this first, and then add the affirmations and visualisations as the icing on the cake!

3: Stop chasing shiny baubles

With one business idea I focused far too much on what we would do once we were making 100k a month from memberships. Never mind I'd neither finished nor tested the website design.

Because I was so caught up in chasing shiny baubles and living a fantasy in my head, I lost sight of what my customers needed and how I could provide that as a business. So, even

though this business idea had an investor and it was a great concept, it failed because I lost sight of my customers' needs and didn't focus on growing the business.

Looking back, I realised that I created the whole business idea just because I had a fear of needing more money and being seen as a success. Deep down, I wasn't passionate about the topic or business idea. I was desperately scrambling to provide myself with the financial security I needed. My energy was all off, and I was chasing. I'm not sure any business would survive for the long term if the core reason for creating it was just making money and nursing your ego. That approach ignores the customer.

Understanding your customer is so important. Once you can master fulfilling their needs, your business will grow rapidly. With Operation Goddess, I talk to our customers all the time. I get feedback constantly. My focus is always on helping our clients change. The money comes as a result of their change. My focus has 100% flipped.

I now have a clear growth plan for both of my businesses. I set time aside to visualise and allow my shiny baubles to be set free and for my creative energy to thrive. I then work with my business partner on a strategic plan to make it happen.

4: Don't get caught up in nonsense

In the small business and coaching world I've come across some awful people. I can't bear to see another person try to sell me their 10K program whilst sitting on their Ikea sofa in Primark clothes. It's insincere, fake, and they are full of shit.

Don't get me wrong, I love a bit of Ikea and Primark, but you get my point.

When I was chasing shiny baubles, I used to be a judge at a speakers' association, and it was full of these types. Oh, and be

careful of the well-dressed ones funded by their husbands or mummy and daddy.

Gosh, I sound so bitter but trust me, these fakers will suck your money and fill you with crap. Don't waste anything on these people.

I used to know one so-called business coach who just moved out of London because he couldn't afford the house prices. This is a guy who had a 10k and 100k program. So that went well then! The fakery just makes my blood boil.

Don't buy anything from these people!

Don't become these people!

I realised that these people all tend to move in the same circles, so they're just buying each other's courses, and no one is progressing. It's like some weird marketing con.

The good news is that when I stepped out of this, I started to meet real businesspeople and real coaches. And when I say real, I mean ones who have achieved great things and share what they have mastered. They are not bullshitters, nor are they chasing shiney baubles themselves.

If you heal your co-dependency and abandonment wounds, you will see these idiots a mile off. I'm still slightly angry about how much time I wasted around these folk, but if my experience can help you see the red flags, then I will be happy.

5: Pay for experts

Don't spend hours of your time trying to do things that aren't your expertise. If you need a job done that will directly make you sales, then pay for it. I'm not talking about your account Excel sheets or creating pretty pictures for your Instagram; I'm talking about making sales. This is where your "cashflow" and "job" money comes in.

If you need to pay someone to do something to make you a

sale or gain a client lead, do it. I wasted months posting artwork or making my website prettier when I needed to be focusing on making sales. Your business should be doing something every day to create sales. If you aren't the person to do that, then hire them. I can't stress how important this is. You can trust the universe all you want, but you still need to move your feet. Action has to be taken, and this is when you have to step into a practical reality.

6: Create your well-being council

I work with a psychotherapist who does Reiki, a Theta healer, a psychic, a Chinese doctor and a business coach. I'm in a 12-month mastermind. I also have three successful business people that I go to for support and advice.

My "well-being council" is a beautiful mix of woo woo and realistic experts who keep me healthy, grounded, and focused. I suggest that you find your team. It will take time, but once you do, you will always have the right person to go to when you need them.

Final Thoughts...

Whatever your current business dreams or predicaments, remember that the challenges never go away; they just change as your business grows. If you heal your wounds, you will be strong enough to handle anything that comes your way.

And remember, business is tough, so you should love what you do. Find that thing that sets your heart on fire, and most of the work is done.

You are amazing. Love yourself first, and the rest will follow.

BIO:

Claire Anstey is a therapist and entrepreneur specialising in self-empowerment and mind, body, spirit. She helps women with emotional eating and body image, and is a trained Kambo practitioner.

www.claireanstey.com

MY JOURNEY TO FOTOGENIX

Clare Levy

From very early on in my working life, I always envied and admired people with their own small businesses. Of course I had no idea how much hard work it can be when you are in charge, and to reap the benefits from it. I thought I saw total flexibility.

I grew up in a small family business. In my early teens, I was roped into cleaning cars. My parents owned and ran a garage, selling and servicing cars. They worked hard. In the early days we sometimes went without luxuries but it educated me of a work ethic where 'you can only get out what you put in', and 'hard work and belief will pay off'. We had some great family holidays abroad. It was my travelling as an adult that led to my decision to become a photographer! Experience of working in large companies led me to become self-employed!

'What do you want to do when you grow up?'

This is such a common opening question that people ask children, and it never goes out of fashion. As a child, I thought I would be a hairdresser! Never in my wildest dreams did I think

I'd be a photographer. Growing up in the 70s and 80s, I remember people of this profession were middle aged men with grey beards, dressed in suits and odd coloured ties! Also I was brought-up with the belief that putting an umbrella up indoors was unlucky! Nope!

However, in my childhood I would often pick up a camera. It didn't matter what sort it was. My parents had a small Kodak Instamatic. The chance of taking more than a handful of decent pictures was potluck. It was a gamble! They were like the disposable cameras in the 1990s.

In my final year of school, I sneaked my Dad's camera onto the school bus and took pictures of everyone. I still had no real photography ambition when leaving school. I had given up on GCSE Art as I remember hating the ongoing papier-mâché projects, and thick smelly paint!

I couldn't wait to leave school and start work. My first job was at Debenhams. I was put on a Retail Training Scheme. This gave me opportunities to work in different departments on 3 month placements. Assisting on the shop floor was fun. It taught me how to deal with many different types of people, both staff and the general public. This was a time when I really learnt how to adapt to different needs and situations. It developed my confidence and sales skills. Shop assistants and sales people in large companies are trained how to 'up sell'. This can be a useful skill in running your own business. I liked my placement in Display best. This was dressing the mannequins and positioning them correctly.

I chose to go back to study 3 years later. I joined a Business course. Funnily enough, alongside a lot of other people of the same age as me, who had also taken time out in a real work-place. I completed the course and went to work in office sales. I developed a love for travelling during this time and made it an ambition to go. My days of travel and working overseas lead me onto Photography in a much bigger way, particularly people

and landscape. I took pictures of local people, if they allowed me.

I decided then that I wanted an arty or creative career, but also liked selling.

I went on to do a full time photography course in Bournemouth, this brought me back from working abroad. It was time to knuckle down and think about my future. Turning 30 wasn't too far away. I completed the Photography course with Distinctions, and took a job in selling advertising. I wasn't brave enough at the time to start a business with very little cash. I progressed to joining the housing ladder, getting married and putting up with my sales job! I'm a loyal person and it felt foolish to give up a decent wage. When my rut was finally broken with redundancy at the end of 2005, it pushed me into a decision to set up my own photography business. I had been so miserable in my job. What did I have to lose? I have never looked back since!

There are so many talented photographers out there who specialise in outdoor family shoots and weddings. Why compete? When I first set up, there were not many local studios to compare to. 'Lifestyle Photography' was becoming very popular; In a studio, the plain white background, taking shots of the people looking relaxed in their casual clothing, compared to the more traditional Victorian look of sitting still, looking forced to smile at the camera, dressed in one's Sunday Best!

So 2006 was a big year for me! We converted our double garage into a studio by boarding the walls and painting the whole room white. I invested in my lighting, camera, logo, website and promotional stationery. I then invited friends round with their children to practice on. Then, in late Spring I discovered I was pregnant with our first child! Luckily I felt well with the pregnancy and it motivated me to work harder so that I had a small business ready to go back to after he was born.

In April 2006, I did my first family shoot with people I didn't

know personally. People were actually easier to photograph when the children were strangers to me, as I was to them.

Amongst the small studio photography businesses in the area, there was also a photography franchise that had 3 studios in the surrounding bigger towns. It felt like they led the market. They seemed to have a powerful brand that dominated, or so I thought. They had more overheads and set their prices very high. I found their work very inspiring but learnt that their prices weren't for everyone.

I was able to charge less, making the photography more affordable for another target market. I had to offer lower prices and promotions to get customers through the door to show them what I could do. Over the years, my prices have risen gradually as reputation has grown and we all deserve to be paid for our time. The shoot, the editing prep for the viewing, more editing to make the images 'print perfect' and the final purchasing from suppliers and so on. However, I still always endeavour to be fair and reasonable.

Finding your target market can take a while. They are not always necessarily who you would expect. Scattering leaflets all over town didn't seem to work very well so I contacted all of the nearby schools to ask if I could have a stall at their Summer Fayre. Most of them allowed me to, along with other local businesses and their stalls. This worked better. The right exposure is so important. I started to book photoshoots with the families on meeting them at events. I believe it was because they then knew who they were dealing with, and bringing their children to. I get most of my business from public events, and most importantly 'Word of mouth' and trust.

Psychology is something that I've always been interested in but never actually studied it in school or college. The photography course taught me the technical side and encouraged creativity using different lighting, flash and practising camera settings. We were never taught how to deal with people in a

shoot. However, it has become very prominent and important whilst in the studio. I learnt very early on that it is so important how you make people feel. Having our picture taken can be daunting and sometimes embarrassing for more sensitive people. There is so much more mental awareness these days about mindfulness. We never know what may be going on in someone else's life. Of course it is none of my business if it's a customer, but we should never judge. I can always find something to talk to people about. I try and keep it about them. I may notice something they are proud of like a piece of jewellery, a tattoo they have showing, or something they have bought along such as a musical instrument, trophy, or favourite item of clothing. The person is normally happy to chat about the said item. The conversation then distracts them from any anxieties they may have had. The happiness and interest as they talk really does reflect in their facial expressions and they are more relaxed. At this point, they often don't realise I am taking their picture, which keeps them looking natural. Most importantly, I try and get them laughing by dropping in my own brief comments and experiences. Everyone is owed a laughter shot. Nobody really likes awkward silences either. I believe I have gained this skill through many years of working and travelling with different people.

Surely if I can get a 2 year old to adhere to what I'd like them to do, then the same must apply to a dog, right? I'd been photographing families and children for a few years when suddenly I had quite a few keen dog owners ask me if I do dogs. I didn't want to say 'No' and fancied a new challenge! They are part of the family after all. I've never owned a dog but I do like them. I started to notice a lot of people seemed to get a puppy when their last child started school. I soon became confident that I could incorporate the same strategy with a dog in the studio as a 2 year old child: basically treats and bribery! Having

liver treats hanging round my ears and lens was far less pleasant than holding up gummy bears though!

Having the studio has meant I have been able to branch out and do product photography! These items don't move, talk or run around! I have created the perfect set up to take pictures for other business websites ensuring images are detailed, colours are accurate and match descriptions. Amazon have very strict requirements for pictures on their site. White backgrounds must be clean and products have to be a certain size in the frame.

Working at my small business is not always easy! Marketing can be tough! Any job that we thrive to do and want to go on to sustain a good reputation, seldom isn't! We are never promised that. But it is rewarding! It's rewarding when my customers are happy with my work and their purchase. Some of them cry with joy! Our own hard work can reap the benefits wholly. Fulfilment is felt when I have created most of the work myself, and followed the formation of a value chain from start to finish.

When I do events these days I collect the contact details of people who are interested. This way, permission is granted for me to call them. There are times when it can take a number of phone calls and emails per person before they book due to their busy schedule or commitments that make fixing a date challenging. When clients become customers, most of them appreciate what I do so the patience in keeping the contact really does pay off. I love what I do and plan to stay with it until retirement!

BIO:

Clare own FotoGenix Photography and is a Studio Photographer. She works from her beautiful purpose built studio at the bottom of my garden. Clare photographs families with children, couples, people of all ages and dogs, model shoots for all profes-

sions and dance shoots for ballerinas. She also has a perfect set up to shoot products for companies and online businesses. She does a lot of work for sales on Amazon because the requirements are very strict. Clare prides herself on being friendly, used to many different people and aims to make my sessions fun and relaxed.

www.fotogenixphotography.co.uk

DESIGNING YOUR LIFE

Kendra Beavis

E ntrepreneurship was always the end goal for me. What I didn't realise was how being my own boss was going to support me and allow me to thrive through all the twists and turns my life took.

I knew I wanted to be a business owner from as early as I could remember. I had grown up in a three-generation family-run business, McCarrick's Dairy, which gave me early insight into what owning a business really looked like. I watched my family break the mold of how these stores were traditionally run and create an iconic establishment that made a big impact on its customers and the community. This gave me that entrepreneurial itch and was the beginning of understanding the foundation for how I wanted to run my business in the future.

My plan was to work my way up from coffee intern to designer and someday become the boss girl at the helm of my own studio. I wanted to be free to raise my kids, travel, work from anywhere and create exciting projects with incredible

clients. But the first steps into the design world were disheartening and rocky. I had landed "the job" at a trendy Manhattan design studio, but the toxic environment that my boss had created was a big red flag and it showed up in every area of his business. I saw unhappy clients, a team that was crumbling and shrinking revenue. I was confident that I could create something better by combining the lessons learned here and my experience with my family business. So after a year, I quit my job.

While some would look at this as a failed attempt, I knew it had given me real-world experience and insight into how to and how not to run a design studio. "Failure" can actually be a best friend. In fact, I don't subscribe to the negative emotions around failure anymore. I have learned to incorporate the idea of "failing fast" into my growth process which has given me the confidence to try new things. I'm no longer afraid to take chances, because if it doesn't work, I take the lesson from it and try something else. When you dispel the fear around that word and possible outcome, you're then empowered to expand more without hesitation. It's a very freeing feeling.

I started MOKA Graphics shortly after leaving the city. I was on fire with inspiration after a year of analysing a business that wasn't thriving. I'm sure a lot of you reading this have had or are having similar experiences. You know in your gut that you can solve something in a better way. That's the fire of an entrepreneur which becomes the driver behind trusting your intuition and taking the leap to create it. I knew I was a talented intuitive designer with a knack for personal connection. But I didn't know too much about the mechanics of running a business. I studied others in my industry for guidance on structure and methodology. I was tenacious and knew if someone else had done it then I could too. As Marie Forleo always says, "Everything is figureoutable". And now with Youtube and all the

digital tools that are available to us, that quote has never been more true.

An important step for any business is to spend the time to clearly define the core values and mission of the business. This is our guide for making any decisions moving forward. Our core values became respect, integrity, service and fun. That means we are committed to providing a high level of service for our clients. Always operating with integrity. And keeping joy at the center of everything we do. Our mission is to create strategic impact for our clients while keeping the process easy and enjoyable.

MOKA has been in business for over twenty years now but it's looked very different from year to year. I think this has been the most freeing part of the experience of being an entrepreneur. As my life has changed, so has my business. I've been able to morph it into what I needed it to be depending on how I needed it to support my life.

In 2011 I was two months pregnant with my second child and I asked my ex husband to leave. I was miserable with him and knew that I wanted something better for my son and daughter on the way. Having MOKA made the decision a little more achievable. I wasn't pinned to a salary where I would have to get a second job to support my kids and afford my home. I had the freedom to expand the business to support us on one income. I brought on new team members, accepted more clients and created more abundance. I was able to pay my mortgage alone, be the kind of Mum I wanted to be for my kids and even travel with them.

Over time, I started to fall out of alignment again. I was accepting work that created a lot of stress for myself and my team and I had moved the studio into a larger space. I didn't notice it happening, but I was saying yes to things without evaluating if it was in line with my core values and my vision. Revisiting that core is so important as you grow. It's easy to get

caught up in creating what you think your business should look like instead of holding tight to what's true for you. I was admiring other agencies and thinking I had to have the same fancy office and hipster team even though it didn't feel quite right. I had some major blinders on and I lost team members over it. I started to feel like things were spiraling out of control but I wasn't sure how to get back to my original vision.

When quarantine started here in New York in 2020 everything changed. I needed to help with homeschooling the kids and didn't have the option of going to the office. I thought things were going to fall apart, but instead, I slowed down the amount of work we were taking on. My team started working from home. The kids felt supported and we spent more time outside taking daily hikes. My team was happier. The work was coming together quicker and more efficiently. We were firing on all cylinders and doing better than ever. But how could this be? We weren't in a fancy office or taking team selfies over sushi lunches in the conference room... I was sitting in my home office in sweatpants and slippers, serving my team and my clients better than I had ever done before while still being able to take time for myself and my family. But I was still hesitant to close the office. I was struggling with perception and judgement again. I meditated on this a lot. I finally came to this realisation. We never actually know what is going on in someone else's business. It might be right for them and their team, but we need to trust our intuition and do what feels right for us. I decided to officially close the office in December of 2020. Trusting my gut resulted in the business tripling its profit in 2021.

The next stop for me is starting a second business. MOKA is supported by a great team that I will continue to lead and guide but life throws you curveballs and I've navigated through a few major ones. I want to show women how I was able to not only get to the other side of darkness, but thrive and create a life even better than what I had imagined. Now I have created the

"Brand New You Method™" to help women move through trauma and create a foundation for themselves to build their new life. I can't wait to launch this company and see how it's going to inspire women to transform their lives and create their own impact!

All these choices have been guided by establishing my core values and beliefs. I have spent a lot of time working with guides to help me define who I am at my core and how I want to feel every day. After I did that, it was easy to see the right choices because they lined up with what I had already defined as my center. One of those core beliefs is that joy is at the center of everything. If it doesn't bring me joy, I don't do it. Sounds simple and maybe even silly, but it's been a guiding force and hasn't steered me wrong in twenty years. We are the creators and get to make the rules, so why not make it fun!

I hope my story inspires you to create the confidence in yourself to follow your dreams. I'm no different than you, maybe just a few steps ahead. So let my story be a guide for your next steps. Do the work to build faith in yourself to create iron-clad confidence so you can take that leap. You can build your business the way you want to live, not the way you want to make a dollar. Life is too short to be unsatisfied and living in the "what ifs". You deserve true happiness, joy and freedom to live your best life. I know you can do this and I hope you have tons of fun creating it.

BIO:

Kendra Beavis is the Founder, and CEO of the brand strategy studio, MOKA Creative. Although her business has been very successful, her proudest achievement has been her personal growth. She survived a tumultuous marriage, battled with several addictions as well as navigated the path through single-motherhood.

Each of these moments was a fork in the road for her where she could have turned to despair and darkness. However, she didn't just persist... she thrived! Kendra has learned how to use her biggest challenges as fortifiers — Her traumas have become catalysts for radical growth to move forward and live her best life. She lives on Long Island, USA with her husband and two kids.

www.kendrabeavis.com

28

MOMENTS THAT MADE ME

Sofie Atkins

L ife is made of moments. Moments that define us, moments that we may choose to ignore, moments that we once thought insignificant only to later realise that they were the monumental moments.

When I was first trying to understand what my 'why' was for wanting to start my own business, I spent a lot of time reflecting and searching for what I thought might be the right answer. I spent time looking back at past experiences, thinking about my passions and imagining what I wanted my future to look like. What really got me to my 'why' was opening myself up to be able to see the moments that had taken place in my life so far. Moments that at the time weren't particularly distinctive but turned out to be the monumental moments that I didn't want to miss.

I remember lying on my back, hot and sweaty, staring at the ceiling of a dance studio with the biggest grin on my face. It was about 8:15pm on a Monday night and it had been so long since I'd felt this way. I felt alive, not just in the sense that my heart

was beating and oxygen was travelling through my lungs, I was alive and I was back in the room. I was awake, I was present and I felt happy.

I can recall staring at the high ceiling, feeling a soft blanket of calm enveloping me. I could feel my body softening into the cool studio floor, I could smell the warm Autumn night air flowing in through the side doors, I could hear my breath and a soft gentle voice leading us through our cool down. There was electricity coursing through my veins, a bubbling in my stomach and an overwhelming sense of knowing. Knowing that this was where I belonged. This was what I was meant to do.

Prior to that dance class, I was spending my days working in a 9 to 5 office role, in an industry I had no interest in. Every day was the same and I spent it sitting still at a desk, (and for anyone who knows me, this is a hard task for me to live up to five days a week) with little freedom, someone always watching over my shoulder and no desire to strive for something more. Whilst I couldn't recognise it at the time, I wasn't where I was meant to be, nor was I living up to who I was meant to be.

Looking back, it's amazing to see how one moment or even a series of small moments leading up to it can change the path that we are on. I walked out of that dance class, which I almost didn't go to, feeling like a different person to the one who went in. Walking out of that studio, I knew something needed to change. I knew I had a greater purpose than this, I just hadn't been able to see it clearly enough before then.

Movement has always played a big part in my life. I've always danced, for no reason other than it was fun and I loved it. I dabbled in an array of different dance styles; your typical Modern, Tap, Ballet, Jazz and a bit of Ballroom. I carried it on through college and went on to study dance at university and received my bachelor of arts with honours degree in Dance and Choreography. What was most important to me, was not the qualifications I gained, it was the way that dancing made me

feel. Learning to dance helped a quiet girl come out of her shell and learn to believe in herself. Something I had forgotten up until that dance class. That little girl learned to have confidence in her own abilities, she came to understand that it's okay to make mistakes, she learnt that determination comes from within and that most importantly, that she had greatness inside of her.

So, what did I do? Like the impulsive and slightly impatient person that I am, I jumped in feet first. Having never taken a Pilates class before, I booked myself in for a Pilates training course, which sounds somewhat foolish. What's even more foolish is that I finished my degree believing that I never wanted to teach. The idea of dancing in front of a room of people I could handle, however standing up in front of a group of people every day as my job, talking and leading them through a class made me feel sick to my stomach. But here I was, immersing myself in my training to become a Pilates instructor; taking as many classes as I could and totally falling in love with a new way of moving my body and the prospects it had for my future. Now, I'm sure somewhere along the way there was much more to-ing and fro-ing about this decision; moments wrapped up in self-doubt, uncertainty and a lot of horrible, nervous stomach feelings and stumbling over words the first time I had to talk in front of the group during my training. Yet now I look back and just remember the girl who went for it. The girl who wasn't afraid to stand at the front of the dance class, who believed in herself and took a step into the unknown.

To cut a long story short, I qualified as a Pilates instructor and set off on the quest to make this my career and passion. I had no business plan, no real plan at all to be honest. I didn't think, I just did, which is something I hugely admire about the person I was at that point. Learning as I went, I set up my own classes, I took on classes at local leisure centres, I spent more

time in my car than at home and slowly but surely, I was able to leave my 9 to 5 job and call myself a Pilates teacher.

Success!

That's not really where the story ends, it's only where it begins.

I spent the best part of six years teaching for other people. I found a teaching position that I thought would be my forever job, but it turns out that it wasn't meant to be. Somewhere along the way, through the long days of teaching, the physical and mental strain I was putting myself under, the exhaustion and not being able to turn my brain off, I felt like I had lost my way again.

Something I have always tried to stand by is that if what I'm doing no longer makes me happy, it's time to make a change. Often easier said than done and as is with life, it's very rarely so cut and dry, but the time came where I was no longer feeling fulfilled.

I felt out of sync with my values, I felt off balance with my work and home life set up and I was worn out having to live up to someone else's expectations. Towards the end of my six years in this role, we found out that a member of our family was very unwell and this really was the next moment for me. Life isn't a given, we only get one and well fortune favours the brave right? So, I lined up all my ducks in a row, reached out to someone who could help me find my way and handed in my notice ten months later. I don't know about you, but, circumstances allowing, I find that I have to put myself in a sink or swim situation to be able to move forward, otherwise, it's too easy for me to continue bumbling along on the same path. It's here that my business, The Joyful Movement was created.

The Joyful Movement was created over the space of nine months and that nine months was filled with family illness, fear of loss and a lot of tears. But what kept me going was the same

thing that taught a quiet little girl to believe in herself and keep going, movement.

I remember one morning deciding that I would follow an online workout that I found on YouTube. I think it was a HIIT/Boxercise type class and at the end it had what's called a finisher. This finisher was 60 seconds of high knees and punching the hell out of the air. With the instructor's voice echoing in my ear, telling me to keep going, knees up, push through, 30 seconds to go, I felt a strange sensation boiling up from inside. All the fear, pain and uncertainty of the last year started to pour out and my cheeks became wet with tears. Punching and punching I kept going, overwhelmed by the wave of emotions flowing out of me. The timer finished and I slowed, taking a moment to absorb what had just happened. I felt a huge release and once again I was reminded, this is why I'm doing what I'm doing. There's a saying, which is particularly well known in the Pilates world and that is that movement is medicine and in this moment I truly felt it. Movement has the power to heal, to lift us up from our lowest points and prove to ourselves that we've got this.

Movement has brought me so much joy and it was this joy that I want to help other women to experience. This was and is my 'why.' Whether that be in finding solitude and carving out an hour in her week where she can be herself, decompress in a calm space and take part in a class that will not only allow her to take care of her body but her mind too. Or for the woman who wants to rediscover that she is strong, more than capable and can come and be in a space with other like-minded people who are also ready to re-energise, find their confidence and ignite the fire inside them again.

The Joyful Movement started as two Pilates classes at my local village hall and just over two years since the start of that first class I have been able to expand my classes, create an online membership and a monthly Pilates subscription. There

have been many moments of being a small business owner that have felt tough, that have felt ridiculous, that have brought me overwhelming amounts of frustration, questioning and "what on earth do I do now" moments. Yet these past two years have also been fuelled by a sense of purpose, fulfilment and joy. I feel like I am doing what I was made to do and I'm so glad for all of those moments that brought me here.

BIO:

Sofie gained her BA (hons) Degree in Dance and Choreography from the University of Chichester before qualifying as a Level 3 Pilates Instructor in 2012. Sofie launched The Joyful Movement in 2019 and set up her first classes in her local community hall in Burridge, Southampton. In 2020 she qualified as a pre and postnatal instructor and loves that her role allows her to work with an array of wonderful women, all in different stages of life. When Sofie isn't teaching she likes to spend time at home with her family and taking trips to Cornwall, where she plans to one day own her own Pilates studio that's just a staircase of sandy steps away from the beach.

www.thejoyfulmovement.co.uk

ACCEPT THAT SOME DAYS YOU ARE THE STATUE AND SOME DAYS YOU ARE THE PIGEON

Charmian Heys

One fact to know about me at the start of this chapter is that I have NEVER wanted to own my own business or work for myself. It sounds crazy for someone who has built their own successful business, but I have always convinced myself I am a born right-hand man.

I have worked for some seriously excellent people. Excellence in attitude, excellence in how they conduct themselves professionally, and excellence in how well they know their noodles (stuff) – it has been a privilege.

I want this chapter to speak to the people who feel like I did (and still do) and know that in life like-minded people find each other. If you can bring your strengths and skills to a business, you can only grow.

To look at my professional present, I have to look at my professional past; I am a person who loves routine and loves to find ways to do things more efficiently – this is what attracted me to working in accounts, but it also led to me working in two places in a 20-year period.

COMPILED BY TRUDY SIMMONS

For my first 'proper' job I was working in a stores department for a manufacturing company in Portsmouth. It was a great role, but I wanted to do more. I spoke to my superior and a few other people in the company, and eventually I was given the opportunity to work as an Accounts Payable Administrator alongside my stores role!

If you understand the accounts department structure, you will know it is the lowest rung on the ladder, but it was a start! I was handed a filing tray overflowing with paperwork, and I was told "some of these have been paid, some have not and the rest we are unsure about". After that, the person who handed it to me walked away! It was FANTASTIC! I loved it, and eventually the role grew until it became my full-time position. It is true that if you find a job you enjoy, it doesn't feel like working!

In true big company fashion, we encountered regular changes of "management", and when the latest round of changes took place a new management team were brought in, including a young relatively newly qualified Financial Controller – he was instrumental in pushing me to get qualified in accounting and showing me the benefits of having a routine for busy periods such as month-ends. I continued to work for the company for another 7 years, until I became the Assistant Management Accountant. In that time, I had finished studying for my Accounting Technician Qualification and started to wonder what to do next. My boss was a young man still making his own professional way in the world; I knew he would not be going anywhere any time soon.

My partner at the time, was a dentist who had just had the opportunity to buy a 50% share in the dental practice they were working in – this was a great opportunity for them as they had been working there for years, but it meant when the current owners left, the position of Practice Manager (PM) would become vacant. At home I would talk about my work dilemma

and the solution to both our dilemmas was for me to take over the PM position.

I know what you are thinking – it is a random move from accounts, but I could see that I could still do the day-to-day accounts, which would allow me to maintain that skill. In addition, I would have the opportunity to grow other skills like people management. All of a sudden I went from helping to manage two part-time employees to managing a team of 14. The learning curve was steep as hell!

As a PM you need to be the HR department, the customer service manager, facilities manager, dental nurse and book-keeper all rolled into one! It was great fun, and I developed skills I had never had a chance to use. I also gained new skills (like dental nursing), and I was happy.

During the next five years I was there, my partner became my ex (which is a whole chapter in itself!) and moved back to their native Wales, and a new dentist called Mark took over their share. He was all about reducing costs and looked at the PM position as an unnecessary cost. The remaining dentist said to him, "give it a month and if you still feel the same, we will talk". Needless to say, he decided against cutting my position.

We all worked happily for a few years, but it all changed in 2013. Sadly the dentist remaining from the original partnership was diagnosed with an aggressive form of cancer, and in a really painfully short time he sadly passed away. Inevitably, this caused me to think about what I wanted to do, as working in the dental practice was very painful. Neale was more than a boss to me; he was a father figure and a lovely guy.

I decided I wanted to return to work in an accounting position, and after having only two places of work in 20 years, I went through a phase of working in four different places in three years. My final workplace was my father-in-law's company.... again, that is another chapter in itself. BUT I knew I was unhappy and unsettled. I met my best friend, Teresa (who is a

brilliant Tax Accountant), for a coffee, and when I said I was unhappy in my current role, but I did not know what I wanted to do next she said: "I have an idea; if one more person asks me to do bookkeeping, I will scream, so how about this........" So we came up with the idea of Now Bookkeeping Ltd. In the accounting world there are a number of avenues you can take depending on what interests you, and I found my proactive approach lends itself beautifully to bookkeeping.

In the following months, we took this idea and built a business – I used all the skills I had gained from previous roles, used all the great examples of how to lead from the people I had worked with, and obtained my bookkeeping qualification to add my CV.

The business is now four years old, and we have a great full-time employee called Jennie, we have been joined by Laura as a Director, and we have a list of amazing clients. In March 2020, I thought the business would just disappear because a large number of clients needed to close their accounts with us due to the pandemic, but this year, we have undergone a massive period of growth. I love working with Teresa, Laura, and Jennie because we are all united in the standards we want to achieve for our clients. We hold ourselves accountable for the work we do, AND we are each qualified in our respective fields. It is a comfort for us to be accountable to and reassuring for our clients too.

I never thought for one second we would get here. I genuinely thought it would be a modest business with me and perhaps a part-time employee. I guess that is my point – I never wanted to own my own business because I was always scared it would not be a success because of me not being driven enough. I had always worked for people who were the driving force. But not only is it a success, we are growing, and I am a reason for this. Equally, I am not a particularly entrepreneurial person. I know there are great business owners who are. But I do know

how to run a business. Some people think owning your business means you will not sleep well ever again, or you can never go away and relax. However, if you can put controls in place to help you, you can have some time away which will actually make everything better. Controls include automation. For example, if you can use a system that helps with sending out any standardised emails to your clients, it will buy you back a bit of time. The best thing to help with sleep and time to recharge is boundaries – letting your clients know the times you are working and sticking with those times. Of course, there will be moments that you will need to do extra work that falls outside the set boundary times, but this is so with any job or business – just make it a rarity rather than a regularity.

The point of the chapter title is to tell you that you will have bad days, but there are also days when you will have real highs. Even now there are many days I crave the safety of working for someone else, but if you can build a support system around you and work with some amazing people, it makes the worst days so much better.

BIO:

Charmian Heys is a co-founder of Now Accounting Services Ltd. Her work superpower is bookkeeping! However, she is a jack of all trades and master of a few! She has been married for over seven years now and has two lovely dogs. She loves to eat, so she needs to exercise to make sure she does not get to be the size of a house – when she does exercise, she plays football, hockey and rugby. But she has recently discovered rowing! This AWESOME sport is her new favourite.

www.nowaccountingservices.co.uk

HELLO ME

Jennifer Spurr

Growing up I was such a 'good girl'. I did all the things I was 'supposed' to do: work hard at school, get the grades, go to university, get the degree. Then I landed an exciting marketing career for a big-name company. Expectation and momentum launched me up the corporate ladder so fast I didn't even stop to take a breath. It was expected of me, it was what I 'should' do, so that is what I did.

It wasn't until much, much later that I realised - the ladder I was climbing was leaning against the wrong bloody wall.

On paper I had my life totally together. I was flying in my career as Marketing Manager for some of the biggest Consumer Goods brands in the world. Products I developed hit the supermarket shelves and TV adverts I made aired on Saturday night primetime TV. I knew from the outside my career looked exciting and fulfilling, other people buzzed with excitement for me, but inside it just didn't feel like that. I was overworked and overwhelmed. Where there should have been excitement, I felt fear. Where there should have been drive and vision, I felt paral-

ysed. I had no clear idea of where I was going and I felt I wasn't good enough to be doing what I was doing. But, the only way I knew how to be better was to work even harder. If I was better at my job, then I'd like it more, then I'd feel better about myself...wouldn't I?

Fast forward a few years and my husband and I started trying for a baby. One month turned into 3 which turned into 12. Eventually I became pregnant, but at the 12-week scan the baby didn't have a heartbeat. A missed miscarriage. It was devastating and complicated and sad, but eventually we picked ourselves up and carried on trying to conceive. Another year passed and I was pregnant again. But it was the same story, a missed miscarriage. And then again, for a third time. Throughout this time, work was a crutch I leaned on heavily as a means to avoid the feelings that my body was letting me down. Career-wise, my hard work continued to pay off. But looking back, I can see this period left me feeling totally disconnected from myself.

Eventually after three and a half years I got pregnant and stayed pregnant this time. Which was wonderful and terrifying. Mostly terrifying. Pregnancy after multiple miscarriages is a whole different beast, full of anxiety and fear. I was too scared to let myself hope that the baby might survive but felt too broken to survive another loss. I had to keep myself in emotional limbo just to survive. In the last trimester I felt like I didn't breathe. I was terrified that I had gotten this far and would then lose the baby in labour, it was a dark place to be. With relief and joy and disbelief, my daughter Emmy was born. Then just over a year later, her sister Neve arrived. I felt, and still feel, so lucky. They're happy and healthy and funny and feisty and all those wonderful things.

It was at this point that everything changed for me. Whilst on maternity leave I was having therapy to help me process the impact of the miscarriages. As I started to reconnect with

myself I found I was thinking about my job more and more and what it might be like to do something else. I signed up to a coaching experience that a friend had recommended to me. It was transformative. I felt I made a connection with myself that I had never had before and I finally discovered, and truly understood, what was important to me. I could see how I had been holding myself back from my true purpose. I learnt about my inner critic and listened to what it was saying to me - it was so loud and so mean! Through coaching I heard a new voice, an inner 'me', she was kind, supportive and nurturing. I connected with my strengths and passions and what truly lights me up. I worked out what *my* definition of success looked like - not what I 'should' do or what was 'expected' of me. I found *my* voice, *my* passions, *my* purpose. I found me and it felt empowering.

By the time my maternity leave was coming to an end I knew I needed to tip the balance back. I had recognised through coaching that there were parts of my corporate role that I did love, and parts that I was no longer willing to give my energy to. So, I negotiated returning to work on the terms that were right for me. My company were supportive and offered me a position working in a role I genuinely found interesting and fulfilling. It was three days a week so I could spend the other days at home soaking up time with my daughters. I had time. I had space in my head. I could breathe. I started doing stuff just for me, simply because it gave me joy. I followed my passion for meditation and became a meditation teacher. I was so inspired by my coaching experience that I completed a coaching qualification, swiftly followed by NLP practitioner training and hypnotherapy, as well as other powerful modalities.

The more time I spent immersed in the coaching world, the more I couldn't ignore its pull. I felt I wanted to do something more than Marketing. Something more than helping big businesses become even bigger. I knew if I wanted to stay in this career, I would have to go back to full-time working. The

thought of the 8 til late hustle and never-ending-office-days was no longer appealing now I had two small humans waiting for me at home. I kept thinking, "my two daughters are looking at me as their example of how to live, of what it means to be a woman". So, I made a stand. I refused to be another casualty of the patriarchal rat race or show my girls that working like this was OK. I decided to follow my gut instinct, my intuition, the gorgeous new voice of my inner-me and I made a list.

I wanted to create a business that I felt passionate about. A business that would have a positive impact on the world. And that would enable me to fulfil my dreams, make impactful work and nurture my creativity. I also wanted to be a present and connected mum. I wanted to do the school run. I wanted to be the one my daughters talk about their day to. Who helps them with their homework, takes them to the beach after school and who wipes away their tears. By understanding what I love to do and what I'm good at, as well as what I want my life to look and feel like, I created a business plan that would work for me as much as it would my clients. I finally put my ladder against the right wall. I now run my own coaching and consultancy business.

There are two parts to my business. The first is Life and Business Coaching where I support ambitious women to step into their confidence and power to create a life they love, filled with possibility and potential. My experience as a corporate leader and people manager, combined with my coaching quali-fications and capabilities, helps me to create a safe and supportive environment that enables women to thrive. My experience in brand strategy and marketing also helps me to guide female entrepreneurs as they launch and grow their successful businesses, whatever stage they're at. The second part of my business is brand consultancy, where I help larger businesses to increase their impact and scale by supporting them with their brand strategy and positioning, and by

working with them to develop purposeful and impactful marketing.

Don't get me wrong, owning my own business comes with its challenges and struggles. I missed the safety that came with corporate life at first; the boundless creativity of my team, the supportive hum of an office environment knowing we were all part of something together, and of course, the security of a guaranteed pay cheque each month! I had to build myself a new network and supportive community fairly early on; people who I could ask all my questions to, who were ahead of me in their entrepreneurial journey, who could give me good advice and perspective. It's been wonderful connecting with so many inspiring, supportive people who are walking a similar journey to me. I've also had to learn what boundaries mean as an entrepreneur. I was good at these as an employee, but running my own business, one that I love, where I'm bursting full of ideas, means I would work 24/7 if I could. But I know this isn't healthy or sustainable, so I am relearning what self-care looks like for me as a business owner. And I work hard, harder probably than I ever worked in my corporate role, but it's a different kind of work. Instead of taking energy from me it gives energy to me, it makes me feel alive, I buzz with excitement for myself now.

And the future feels so exciting. I'm planning sustainable growth for my business in line with what my family needs and in a way that compliments being a present and connected mum. My current focus is connecting with and supporting as many women as I can through 1:1 coaching, launching new group programmes and women's circles with the goal of helping every woman re-learn what they intuitively already know.

It's my life purpose that keeps me focused and moving forward, even on the tough days. My ethos is simple. What I want for my daughters is what I want for all women. I want all women to feel a deep, fierce and powerful connection with

themselves. To trust their inner-knowing and believe in their strength and capabilities. I want them to connect with themselves so solidly that they have no choice but to become more and more their truest self. I want women to shamelessly, fearlessly, and relentlessly show up for themselves. I believe that when we step into this version of ourselves we become a shining example for other women around us to do the same. I believe this is how we change the world, first transforming on the individual level and then supporting the future generations to stay connected with themselves. Can you imagine a world where women feel unstoppable? Where women realise their goals and dreams as if they were already given? I can, let's make it happen.

BIO:

Jennifer Spurr is a Life and Business Coach and Brand Consultant for ambitious women, leaders and entrepreneurs. She supports you as you reconnect to yourself, ignite your confidence and power and consciously create a life you love. She takes that same passion and fire to help heart-led, purpose-driven entrepreneurs create and scale thriving businesses through a balance of strategy and self-belief.

She spent the last almost 20 years building a successful career in marketing as well as leading high-performing teams.

She runs her business from Hampshire, UK where she lives with her husband and two daughters.

www.jenniferspurr.co.uk

ABOUT THE DAISY CHAIN GROUP

Trudy Simmons started The Daisy Chain Group in 2010. It was started to support and encourage businesswomen to have a safe space to share their journeys, and to be seen and heard in their endeavours.

Since its inception, the concept has grown to include platforms for women to find their voice and become more visible in lots of different ways. Whether it is attending The Crazy Daisy Networking events to grow your audience, coming along to The Spectacular Online Business Symposium to learn from world class speakers from around the globe, Make the opportunity to speak at The Spectacular to share your wisdom, be a part of the Shine On You Crazy Daisy book series to share your story, or be on the Shine On You Crazy Daisy Podcast to give your story gravitas and hear it in your own voice.

The Daisy Chain Group also offers The Accountability Club for businesswomen to work out how to build momentum and consistency in their businesses by deciding where their challenges are, how to overcome them and what they are committing to for the next 2 weeks - this is GOLD if you are a procrastinator (I see you!), or if you want to grow your business.

The Accountability Club is direct help and support from Trudy with her no BS way of cutting through the challenges and being able to find the next action steps to help you to move forward.

Trudy is known for her engaged communities on Facebook - The Hampshire Women's Business Group (for local businesswomen) and The International Women's Business Group (for any businesswoman that wants or has a global audience).

HAVING FUN in your business is a core value of The Daisy Chain Group. Having fun and TAKING ACTION is what builds you AND your business.

You can find The Daisy Chain Group here:
www.thedaisychaingroup.com
https://www.facebook.com/daisychaingroup
https://www.instagram.com/daisychaingroup/
https://www.linkedin.com/in/trudysimmons/
You can find The Daisy Chain Group communities here:
https://www.facebook.com/groups/hampshirewomens-business
https://www.facebook.com/groups/internationalwomens-business
You can find our services here:
The Crazy Daisy Networking
https://www.thedaisychaingroup.com/crazy-daisy-networking-club
The Accountability Club
https://www.thedaisychaingroup.com/the-accountability-club
You can find the Shine On You Crazy Daisy Podcast here:
https://www.thedaisychaingroup.com/podcasts/shine-on-you-crazy-daisy

EVERY TIME YOU BUY FROM A SMALL
BUSINESS, THEY DO A HAPPY
DANCE!

PLEASE SUPPORT THE BUSINESSES IN THIS
BOOK.

CHARITY LINK

10% of the profits from this book will be donated to Healthcare Workers' Foundation Family Fund. The fund will support the children and families of healthcare workers who have passed due to Covid-19. To donate or support this incredible charity, please go to this link –

www.healthcareworkersfoundation.org

OTHER BOOKS

AVAILABLE NOW

Shine On You Crazy Daisy – Volume 1
Shine On You Crazy Daisy – Volume 2

Available on Amazon, iBook and in all good bookshops.

COMING SOON

Shine On You Crazy Daisy – Volume 4

Available in March 2022 – more stories, more inspiration, more motivation to get out there and do what you WANT to do with your business. We are all in this together.

Printed in Great Britain
by Amazon

70917368R00129